D1572369

For Terry —

Coleggio
e
Pezienza

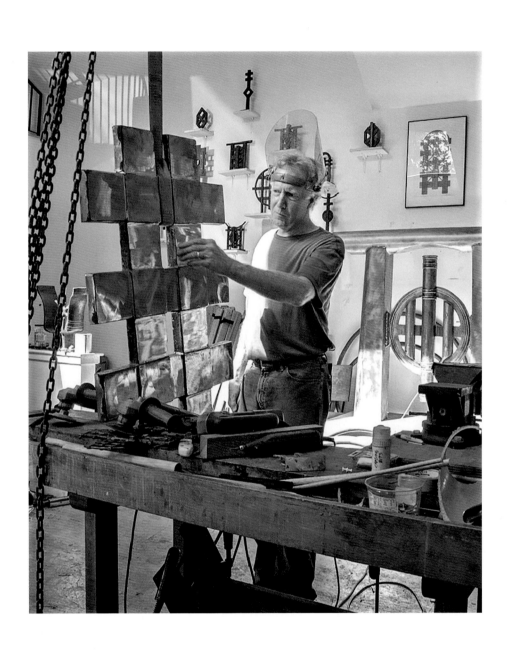

HAMMER AND TONGS

JOURNAL OF AN ARTIST AND SCULPTOR

De Wart

MURRAY DEWART

Jah 2024

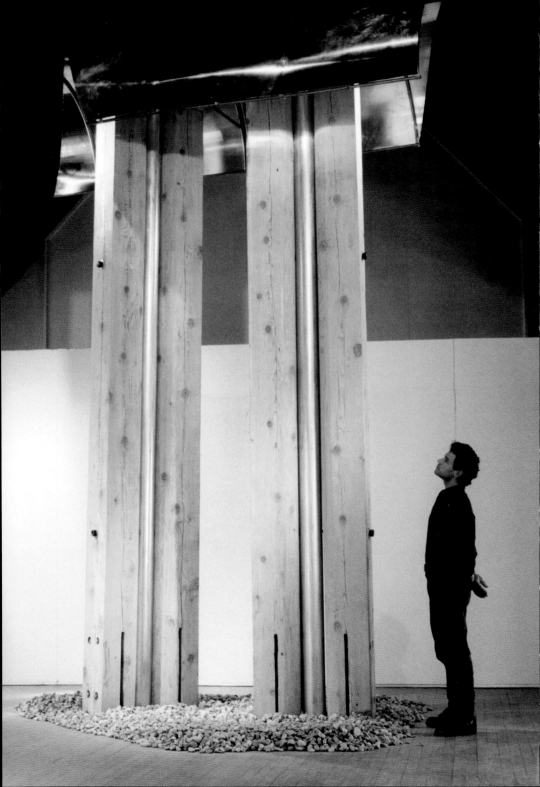

January

In my industrial studio space in Everett, I am working to finish two big sculptures. *Gilead* is ten feet high and one of the biggest bronzes I've done. Mark and Nicole, my assistants, have gone home. I have finished welding, silver soldering, and drilling bolt holes, but there's more polishing to be done. The industrial space—once a bolt factory—has a raw quality, and the winter light is dim from the high clerestory windows. In the big tool bin are all the power tools, saws, and grinders, with carefully wrapped cords, and the welding torches drape from the oxyacetylene tanks. The TIG welder is cooling and the air still has the slightly sweet smell of molten bronze. On the workbench are the three-pound hammers, the leather gloves, and all the measuring tools. On the floor are the wheeled dollies, coils of rope, and a hickory pry bar at the ready. Hanging from an overhead beam are a pair of two-ton chain falls. The tools have a humble, everyday quality, and they keep me constant company as I move and work the granite and bronze, the copper and steel. There is a yearning that dignifies our work as artists, as the poet Louise Glück remarked, though we never know with certainty what it is we have accomplished. We need to stay undiminished by the world's indifference, such as it is, and what we do in our studios must be its own reward.

There is something new and poignant about the sculptures as they near completion, as they glisten, gesture, and soar upward in the dim light. The polished bronze has a high shine, and I am delighting in how the big central disk of *Gilead* fits perfectly in the square opening, echoing something Taoist that I seem to remember. On one column, Nicole has been applying the greenish-blue patina with a torch, and you can see in her brushwork that she is highly musical, and I know she plays the cello. She takes very seriously her craft. The sculpture *Solomon's Gate* is fifteen feet high and has massive red cedar timbers from the Pacific Northwest. I have tried a new technique with its sweeping, copper top that curls like a breaking wave or a pompadour. It is a thin gauge, perhaps too thin, but I am hoping it will hold up. The sculpture goes to a group show at the Federal Reserve Bank in a week. It's a big venue for Boston Sculptors, the group of eighteen artists that started in my kitchen in the late 1980s. I am still making a list in my head of unfinished tasks as I turn off the lights and throw the locking bolt across the studio door.

A week later the opening is a great cause for celebration. My *Soloman's Gate* sculpture soars up into the high reaches of the exhibition hall from its bed of river stones, half a ton that Mark has wheeled in off my truck. A huge picture of the sculpture fills the front page of the *Boston Globe's* Living Arts section, above and below the fold. Christine Temin, *Globe* art editor, has a review that hails our show as "*the finest marriage of*

sculpture and architecture since the opening of the Guggenheim Museum in Bilboa."
My phone rings all day with congratulations. I feel the world's resistance yielding ever
so slightly, and all the sculptors are smiling, slapping each other on the shoulder and
applauding the group effort.

On a disk of copper 3 feet wide, I have etched in formal letters:
ONE SINGLE HUMAN LIFE
CALL IT: THE FIRE INSIDE THE ROSE
THE FIRE REMEMBERED
It is a line from a talk I gave at a big chapel in 1995.

I am married to a beautiful woman, Mary Davis Dewart. Sometimes I can't take my eyes
off her. One day I accompanied her to the stone supplier where for years her landscape
design business had made her a regular customer. The man at the counter asked me, "Can
I help you?" I said, "I am with Mary." With a big smile, he said, "You lucky bastard!"

I remember the restlessness that took me down to Bennington College in 1970, where
I met this beautiful, mysterious woman. She was making steel sculptures and paint-
ing giant canvases. Isaac Witkin was her teacher; Anthony Caro, Helen Frankenthaler,
and Clement Greenberg sometimes came around, and there were great parties at Jules
Olitski's. It was an intoxicating art experience with welded steel the medium of the
moment. The legend and presence of the late David Smith, who had taught there, was
still palpable. There seemed to be no limits on what steel could do. In 1965, Saarinen's
Arch in St. Louis had gone up, and in 1967 Picasso's *Horse* in Chicago was built. In
1969, when some of us at Harvard wanted to start welding steel, word came down that
"Harvard is not going to teach you welding. You can go to a trade school for that." This
was typical of Harvard's approach to the arts while Bennington was light-years ahead.
I told Mary Davis about the cabin and studio I was building in Benson, Vermont, near
Lake Champlain, and a glimmer came into her eyes. She was feeling restless, she said,
ready for an adventure, and always inclined, I have discovered, toward reinvention.
She is a Minnesotan from the great North Woods, strongly athletic, who knows about
mountains and canoeing fast rivers. She laced up her very practical work boots, pulled
back her long hair, and climbed into my truck with her paintbrushes in her back pack. I
could not believe my good fortune, and she has been my life partner ever since.

September nineteenth is my birthday, and it's the day I install my big bronze *Gilead* on
a concrete footing at the elegant home of Dr. and Mrs. Trauring. We roll the sculpture
down the ramp of a rented box truck. It is tall, and it clears the door of the truck by a
scant inch. My client is smiling and pleased. "Murray, you've outdone yourself," he said,
handing me a check for the closing payment, my biggest sale to date. I told him that all

the sculptures before this were preparation. It takes years because there are many technical challenges in making sculpture, and I have been at it since 1969. Back home, I am in the mood to celebrate. I get birthday calls from my sons and my sisters and brother. Mary throws a dinner party with sculptor friends, and I try a new recipe with a marinade for curried chicken. The sense of closure and the delight of money in the bank lasts for days. The studio work has been all-consuming, and I notice areas where I've been inattentive, missing important things on the calendar, birthdays, a meeting at the college, a doctor's appointment, a lapsed inspection sticker on my truck. How can

I have a better balance between my art and my life, especially to be a more attentive husband? I don't want chaos in my personal life.

My big Everett studio is getting problematic. I love the scale of the space, which had been the factory that helped me, in the early nineties, build two winged-horse sculptures twenty feet and thirty feet high. The company went out of business and all the big machines were auctioned off. The factory floor, dimly lit, I share with the McGarry Steel Company. Thieves are a constant problem. McGarry has a huge mastiff that guards the space at night, but some days the dog is still wandering around scaring Mark and Nicole. I go into McGarry's office and ask him to please keep the dog away from my assistants. He is belligerent and indignant and with a violent, sneering curse says, "Get the hell out." I hate this, but I make big sculptures and the situation can't be helped.

Everett is a beleaguered blue-collar neighborhood where I lived for part of my youth. It has the sad feel of a Third World country. There are potholes everywhere, car parts lying in the roadways, tractor trailers idling at the truck stops, and it's always prone to violence. In my middle-school experience in the town, if you showed up at school on your birthday, the principal came to the class and with much joking and laughter gave you a ritual beating, nine whacks if you were nine and one more for good measure. After taking the IQ test of some sort, they lined us up as to how we did, and my poor friend Jackie was way down at the end.

I have a dream about my late father, who was an Episcopal clergyman: he is reading a book with embossed golden letters by the fireplace in his rectory study. His German shepherd, named for a late bishop, is curled at his feet. He seems to take the book seriously as if it's a prayer book, but I see it is mainly a picture book about dogs. I point this out and he smiles his kindly smile. The central challenge and riddle of my life has been being a good son to my father and being a good father to my sons. Waking, I make plans: a visit to Boston for Nate and Caleb.

October

My mood darkens a little with the season as I face the surgeon's knife. Being red-headed and Scotch Irish, I am prone to getting mild skin cancer—basal cell problems that need to be addressed. I call them rogue freckles so as not to alarm my sons. It's not going to kill me but it's daunting, worrying me that I'll be scarred up like an old walrus. The nurse Suzanne in the operating room teaches me a prayer: "Lighten our darkness, we beseech thee O Lord, and guard us from all the perils of this life."

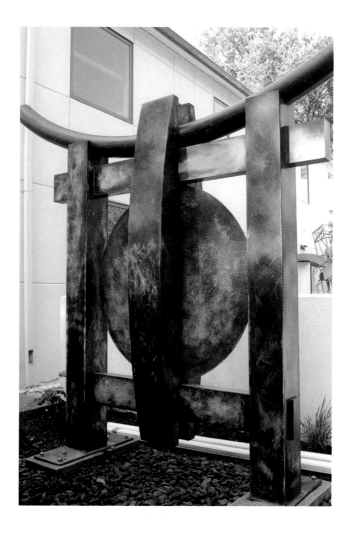

Some light and levity come slowly back into our home and marriage. Our sons fly into town for a playoff game between the Red Sox and the Yankees. Having sold a big sculpture, I indulge in good seats just behind third base. Our neighbor takes our picture in the garden as we hold the playoff tickets and head to Fenway Park, smiling, jubilant, and celebratory. One of the classes I teach is Sculpture and Ritual, and I notice the satisfying rituals of the ballpark experience, the music and singing, the mannerisms of the players, and the ancient enmity between the two teams squaring off. I listen to the nighthawks circling high overhead. The essence of ritual is *making time stand still,* and this family ritual lightens all that needs lightening in the lingering dark.

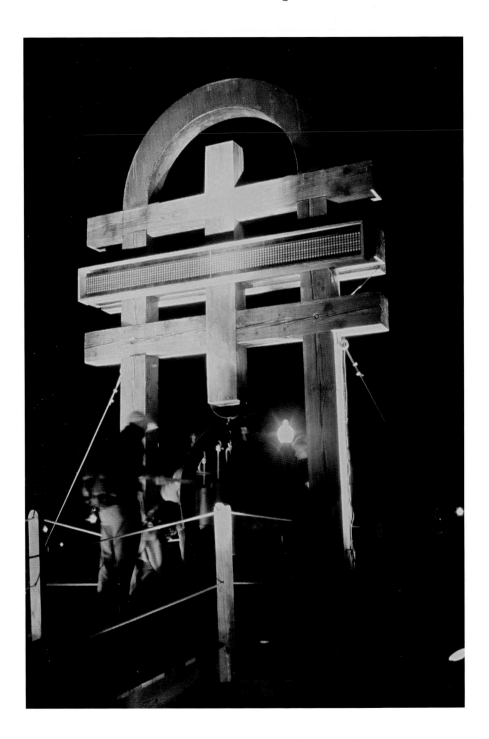

Murray Dewart

November

The renovations to the old horse barn of a studio behind our Victorian house are complete. Mary now has a sunny office for her landscape design business, and my work space has light pouring in from the new skylights. The space lends its serenity to me. I have been working there since 1983, unheated, ramshackle, and dark. My grandfather's West Virginia land was finally sold, and a sum of fifty thousand came to each of his grandchildren. This helped with Nathaniel's school tuition and with the studio. Mary and I improvise an inaugural ceremony in the new studio space and have a weekend marked with quiet harmony and restoration. We quote my cousin Julia Randall, a wonderful poet who wrote, "We are in love with beginnings and the power of beginning in all things."

December 1999

I am at work on a twenty-foot-high First Night sculpture for the Boston Common called *Millennium's Bridge*. It ramps up and back to a bell component for people to ring and two scrolling LED panels with lines of poetry. First Night Boston is one of the biggest art events in the country, and I have been commissioned to build works for more than a decade. There're all kinds of challenges: power, lighting, rigging, security, trucking, crowd control, and copyrights. I find a company that designs the computer systems for Jenny Holzer. Cold weather is a problem, so I build a heater blowing warm air into the panels. Just when everything seems in order, the First Night organization defaults on the payments owed. We renegotiate the fee downward and they pledge payment later. This makes me furious, but years of good experiences with First Night temper my anger. The bridge weighs several tons, and a crew of burly men join Mark in trucking and setting it up. On New Year's Eve, the response is astonishing, with a crowd of half a million people. At any one time, hundreds are waiting in line to ring the bells. In the

heart of the city, I have set in place a simple bell ritual. Hour after hour there's a palpable hunger and yearning in the upturned faces. The mayor comes by and I shake his hand, which seems as big as a catcher's mitt. The television crews captured this, and it's replayed over and over the following day. Long into the new year, people shout out to me, "We saw you on TV." It is not clear if this is of lasting value, but I am a public artist in the public eye.

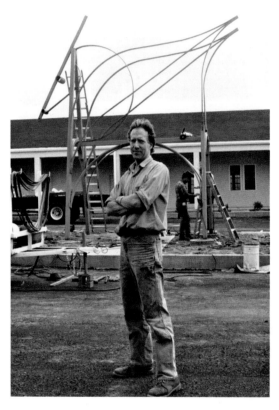

In 1993, I had a leftover sculpture, commissioned by First Night, my *Pegasus Arch*, a thirty-foot-high horse sculpture. When the one-month installation was over it was mine to reuse. I pitched it to half a dozen racetracks, including the Meadowlands in New Jersey. Finally I flew to Las Vegas and found a cheap motel room and a phone book. I called dealer after dealer, gallery after gallery, until finally someone perked up their ears and seemed game. I linked up with the developers planning twenty-five square miles west of the city. They were laying out the roads, the malls, and the housing. There were elaborate negotiations involving half a dozen sculptors from Boston, and they went on for more than a year. It all crashed and burned in the end, but I had pushed my way to a seat at a very big table. I tell that story to my niece Sally whenever she says, "But Uncle Mac, you had so many advantages growing up. You were so lucky."

My view is that you make your luck. When Caleb entered the film business in Los Angeles, nobody asked where he went to school or who he was related to. It was "show me how hard you can work."

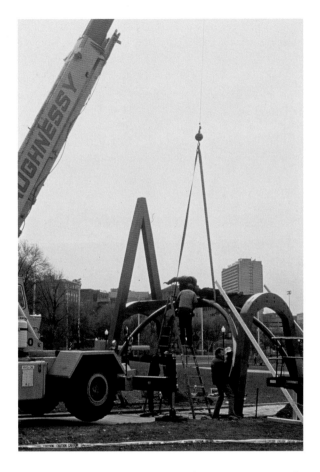

I have come to the view that sculpture is a balance between poetry and engineering. Too much engineering and it's boring. Too much poetry and it tips over, falls apart, and doesn't hold up. The greatness of Alexander Calder, for example, is that sweet spot of balance, the simplicity of his bolts, the poetic use of color. Sculpture has a long learning curve. Mark di Suvero, one of our greatest contemporaries, remarked how David Smith handled his welds as if they were butter. That reflects the many years at his craft. When you see sculptors in their prime, there's an authority to their mastery of craft and engineering. This allows a fluency for the poetic piece of their intention. Flawed works from the great talents are also instructive, because it is a sign of overreach. We need sometimes to make bad sculptures. This is better than repeating over and over what was once successful. Our greatest works are often born of earlier failures, but only when we persevere.

Hammer and Tongs

January 2000

I am chosen a finalist for a big half-million-dollar sculpture commission for the Boston Police headquarters. I go at it full blast, hammer and tongs, riding at night in police cars in the roughest neighborhoods, having long talks, and listening to the stories. An Irish police captain is the organizer, and I banter with him for hours, trying to get at the heart of their mission. I plan for three major elements, design a twenty-foot-high shield-like form in bronze, hire engineers to assess wind loads and graphic designers to Photoshop the presentation graphics. I give my presentation to an overflow crowd of police officers and art consultants. Behind closed doors on a Thursday, a vote is taken to award me the commission. On Friday, the officers meet without the art consultants and award the commission to someone else. I am outraged. I work with the police captain to revisit this, going at it for months, looking for any kind of leverage, to no avail. When the final and absolute "no" is determined, I walk down Beacon Street whacking every telephone pole with a stick, needing to get my anger out. I head to Cape Cod, driving way too fast, then try to clear my head and walk the winter beaches in the freezing cold.

July 2001

Nate and I take a hiking trip into the Green Mountains and on the way out visit my cousin Julia Randall, a much-acclaimed poet who is nearing eighty, in Bennington. We have an intense day talking, sharing family stories about grandparents and stories about artists. She often goes into a ranting mode. She guards her delicate inner life with a curmudgeonly exterior. Few in the family have broken through. My grandfather mentored her and, on his deathbed, said, "Take care of Julie," as she was vulnerable and sometimes too fond of drink. She loves extravagantly Wordsworth, Bach, Henry Moore, Mozart, Yeats, every manner of dog, and everything about Bennington. It's where she awoke to her destiny in one of the very early years of the college, escaping her convention-bound Baltimore parents. She won high praise for her early volumes. Allen Tate said she ranked with the very best poets of her time. "There is no doubt that she will last," he wrote. Now it might be hard to explain who Allen Tate was. She is an Anglophile, taught British literature for many years at Hollins College. "I cannot abide Emerson and Thoreau," she says. "I hate American literature." I say, "*You are American literature*, you are part of the canon of the Southern Pastoral." I was glad about visiting and she seemed pleased and touched. She bought one of my sculptures years ago, and it graces her mantelpiece. It's a life-size walnut carving of a very proud, self-contained woman, bare-breasted in an assertive way, austere, a Joan of Arc without the trace of a smile. I see Julie's toughness now in the face. She helped moderate one of the early quarrels I had with my father. "Go easy on that earnest Christian soldier," she wrote. We spoke across the gulf of years as equals, as artists weaving our respective crafts.

August 2001

All is in preparation for Caleb and Lisa's wedding. It's in an art gallery in Portland, Oregon. *Solomon's Gate* is being shipped in a moving van to function as the bridal chuppah, and I fly Mark out to install it. My mother gives a remarkable toast to the wedding couple, worthy of de Tocqueville. There are family members in virtually every region of the country, and we are a widely biracial, multicultural family. Nathaniel escorts both his grandmothers into the service. Lisa's friend Craig, a psychiatrist, presides over the vows, then we eat and dance up a storm. My family burns up the dance floor at our weddings like it's crazy town. *Solomon's Gate* goes to Clackamas College close by for its new art building, and Caleb and Lisa head to Italy for a honeymoon.

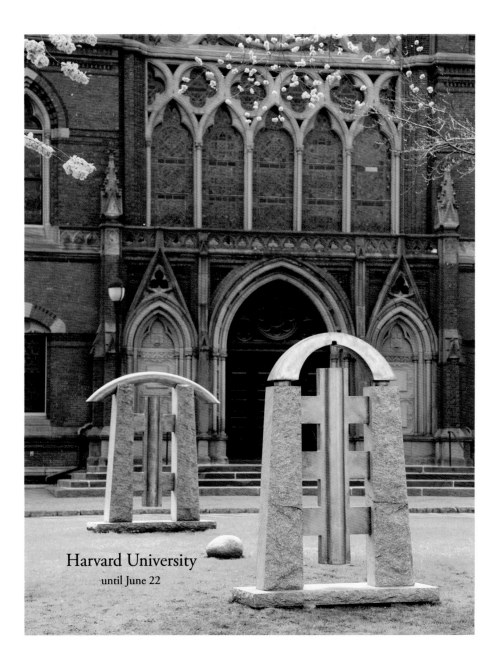

Harvard University
until June 22

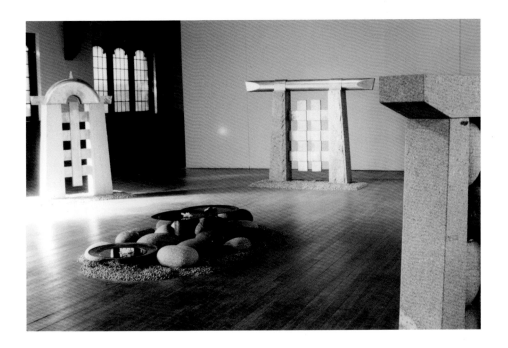

October 2001

My *Merging Waters* exhibition opens at Boston Sculptors Gallery, and it seems by a coincidence to be addressing the national tragedy of 9-11. Five medium-sized sculptures of granite and bronze are placed in a circle. At the center are a pile of large smooth sea stones and three copper water vessels filled with fragrant gardenias. There's a long bench for seating, and people stream in for weeks to sit in contemplation. I have a soundtrack of Buddhist flute music, Gregorian chants, Native American songs, and more. Thirty people come to an interfaith service with an imam and a rabbi. Seventy people come for a poetry reading with Rachel Hadas, Gail Mazur, and Lloyd Schwartz. I have another glowing review in the *Boston Globe,* and my sales break the gallery record. A man arrives in the parking lot holding the newspaper, pointing to the picture, saying, "I would like to buy this sculpture." A man named James Fuller commissions a big bronze, having chosen a design from my wall of small bronze maquettes. I see that I could spend the rest of my life taking *Merging Waters* from city to city. The trauma of losing the police commission mingles with the glow of a knockout success, a sold-out show, and a front-page review. I wake in the night rethinking all of it. Walking down the street, I hear people shout out, "Great review, Mac!" Mary and I take a long Christmas vacation with our sons in California.

Hammer and Tongs

February 2002

Back in the silence of my studio, the shadows of birds pass across my white studio wall. It's a Sunday. I can hear the ticking of the heat pipes and the sound of melting ice in the eaves. I keep remembering the line from Paul Simon: "These are the days of miracles and wonder." Some faces appear at my studio door. It's Jennifer Costa, one of my best students, brought by her mother, who cleans houses for a living. Jennifer is back from the dead, back from death's door with a burst appendix. She has an IV in her arm and an angelic smile, and she shows me some drawings she has done from her hospital bed.

March 2002

At a Boston Sculptors meeting, we vote to vacate our space in suburban Newton and head downtown to the South End, where a new art district is getting popular. At dinner, Peter Haines shares the story of visiting Henry Moore at the end of his life. I say I think Moore had lost his way by then. Beth Galston chimes in, "Someday they'll be saying that about you. When was it Dewart lost his way?" We laugh and swap anecdotes about our current work. I broach the issue of scaling work up from a maquette, remembering David Smith's comment: "Be careful because all the ratios change." I am working on the big bronze for James Fuller, concerned about the ratios.

June 2002

In the middle of the night, our fax machine rings with a call from Beijing. I have been selected in an international competition to build a ten-foot-high version of a sculpture from my *Merging Waters* series. *I am totally thrilled.* I get a sense of being an artist on the world stage. I tell the news to everyone I meet. I visit my mother, and she opens with "Hail, champion!" As Thomas Merton confided to his journal, "The world's approbation seems to be something I need." Tom Patterson is both my cousin and brother-in-law and pretends to have a rolling Scottish burr. "You make the family proud, lad." he says. As I prepare to fly out, there's an article and photo of my work in the *New York Times*. The one cloud in the sky is a glitch with the Fuller commission, which has stalled after the client came to studio. It was before the patina was applied, and the massive bronze somehow frightened him. It feels like a moment of celebration lightly touched with lament.

Beijing is getting ready for the Olympics, and it is a steaming hot summer day. The mayor has commissioned a new city sculpture park, and I am part of a team of international sculptors swarming over the site. We each have a translator and miscellaneous assistants for building our big works in a variety of materials. Gigantic stone saws whirl with a loud clamor cutting granite blocks, as water pours in for cooling. Ancient two-wheeled carts, pushed by hand, carry massive loads with lots of shouting from teams of workers. Girls are translators, carrying umbrellas for shade, talking rapid-fire, laughing raucous laughter, eager to practice their language skills, and excited as if Beijing and all of China were awakening to a new destiny on the world's stage.

My sculpture was initially named *Coraggio*, but from one of Elaine Scarry's books I learn this is the password for political prisoners. Not wanting to complicate my stay in China, I change the name to *Merging Waters*. It has granite, bronze and copper elements, and first I begin cutting the stone to the exact proportions. The Chinese have an

open, jocular manner, like Americans, it is often said, in their easy, bantering familiarity. I wear a wide-brimmed western hat, first because I am endangered by sunburns, and second because I found it useful to embrace the stereotype of the tall American in the cowboy hat. The television crew and the journalists could find me. The visiting dignitary in the black Mercedes had organized an elegant lunch with instructions: "Find the American sculptor in the cowboy hat."

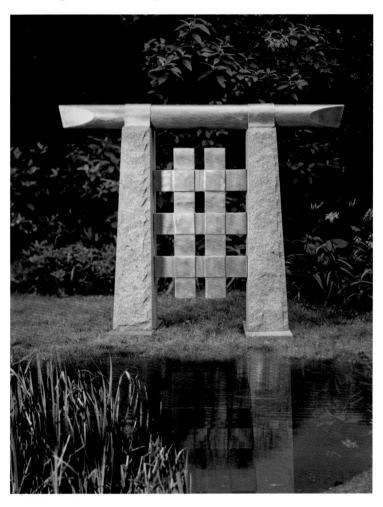

I travel to the foundry on the far side of the city, where the massive bronze center element of my sculpture is being cast. The foundry sits in a walled compound, and in the cramped backroom a dozen women work quietly on small waxes in dim light with a disconsolate air. Wandering cats provide the only charm. There are no power tools to be seen, only broken hand tools, a barrow without a wheel, and forlorn-looking young

men in tattered clothing. Suddenly, I glimpse my bronze piece leaning near the crucible and shout with excitement, racing to touch it with my bare hands, not knowing, even with the sudden shouting, that it is still burning hot. Yikes! The pain does not diminish my delight at seeing the massive bronze, enlarged from the model I had shipped. It is beautifully formed, exquisite in the detail they have captured. I am thrilled to see what I have dreamed up, good to last for a thousand years.

After a long month of work, Mary arrives in China to join me, and we take a break from the sweltering site and go traveling. One morning in Xian, we bike along the top of the ancient city's wall in a silvery mist with a light rain falling. We find an empty kiosk with a silk kimono for sale, the purple and turquoise fabric swirling in a ghostly dance with the wind. We hear music from below the wall, and a group of elderly men and women with stringed instruments practice a plaintive melody. We bike on and I follow behind Mary as she sings the melody at the top of her lungs, hair billowing behind her as she flies over the ancient granite paving stones.

We go to a marketplace, and the wind before a thunderstorm begins to whirl and the light turns faintly purple and a beautiful line of brightly colored umbrellas catch the wind and overturn, and I feel the sudden swirling energy of all the wide humanity coming and going in the stalls of the market with young girls practicing tai chi and mothers nursing children in gorgeous pink and green clothes and the swallows darting under the canopy for protection from the storm, and I feel the moment registering as a *key moment*, some loosening, clarifying vision taking hold, as if this were a revelation about the *pageantry of life*, life's underlying essence shining forth in all its joyous and inscrutable radiance.

We travel to the southern city of Guilin on the Li River, where fisherman ply the currents in long, thin boats and water buffalo stand to be washed in the shallows. A guide brings us to a tour of the caves along the riverbank, cavern after cavern dimly lit with stories about the vague stone forms, monkeys, elephants, and snakes, stories I find tiresome. A final cave catches my attention with its mystery, and I ask the guide to lead the way. "Oh no," he said, "it's almost nothing." I struggle for the right words, as my yearning takes over, and something seems lost in translation. "Please," I say, "I want to see *the almost nothing.*"

The day came for the installation of my nine-ton sculpture with a crane and a dozen helpers. I am given a prominent site by a reflecting pool, and I smile broadly at such an honor. The bronze and copper elements have a high shine, but I went about putting on a patina, using a torch to oxidize cupric nitrate, giving the sculpture an Old World look. I noticed some uneasy sidelong glances from the Chinese sculptors. Something seemed wrong. Finally, my confidant Wei Xiou Ming, one of the organizers and a lead

sculptor, took me aside and let me know why the Chinese were mystified. Americans are expected to make shiny sculptures looking new. Why would I make them look old? He applauded me. "This is good. They need to see this. You have defied their expectation!"

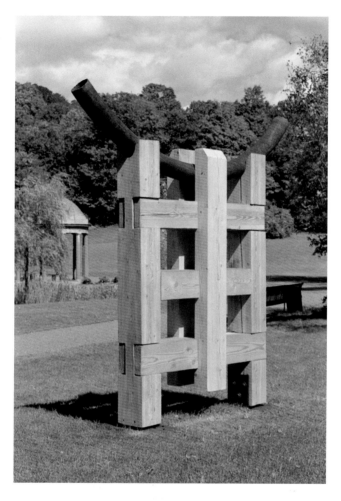

I give a talk to a big forum at the Beijing Fine Arts Academy, with an excellent translator. I explain my growth as an artist, how the language of my sculptural forms had evolved over many years. I try to bridge the vast cultural difference over form, language, and intention. I start to explain that maybe the bronze elements work as vowels and the granite elements as consonants, then realize the concept does not translate. It was a youthful audience with bright, upturned faces. Beginning again, I asked, "Am I looking at the next generation of great Chinese artists?" They nodded. "Are you ready?" I asked. "Yes!" they all said. "Are you ready to build the conscience of the new China in

your souls?" "Yes!" they shouted. "Artists dream the future," I said, "but what about the past?" They laughed. "But there is no such thing as Art with a capital A," I said. They looked puzzled. "There are only artists." They smiled. "But there is no such thing as artists," I said. "There is only the world *lit or unlit* as the sun allows." They applauded furiously, whistling and hooting with laughter.

Later I go on a visit to the studio of Cheng Yung Xian, leading sculptor in China, President of the Sculptors Organization, and a general in the army. He had made many portraits of Chairman Mao and has his own museum. I give him a small bronze prayer wheel with the Buddhist prayer of the Diamond Sutra scrolled in one side, the Twenty-Third Psalm in the other. He is a warm bear of a man, and he turns the prayer wheel genially with big fingers and a mystified smile. "He is puzzled," the translator says. "What are the Psalms?"

October 2002

Back home in Boston, I am asked to give a talk at the deCordova Museum to honor the late John Boyer, a wonderful collector. He believed in art and artists, in sculptors and in sculpture. He believed in one artist, a painter, long after the painter stopped believing in himself. He had a Wallace Stevens kind of refined sensibility, exactly the kind of patron artists need. My tall copper sculpture in his garden is visible from his living room, and there are dozens of pieces by the Boston Sculptors. I went to see him after a stroke laid him low and he could not speak, except for the word *Yes*. I told him stories as he lay rocking and nodding, and I searched his eyes for a glimmer of light as he kept repeating *Yes*. To mark his grave in Lincoln, I will build a low granite sculpture made with massive, egg-like stones I have pulled from the river. His widow thanks me for my eulogy. I used an old prayer of my father's, "Praise God for all we lose, for all the river of the years bears off."

I am a finalist again for another design, this time a Civil War Memorial in a neglected corner of a Boston park. My grandfather once took me to the battlefield at Gettysburg, and I have a sword that he gave me. I made a bronze cast of it and worked it into a sculpture, making castings from my toy soldiers and welding horsemen galloping down the curved blade of the saber. I bring the sword to a class, and there is a moment of rapt silence as I hold it up. I say to the students, "Commit this to memory: *The sword shall not sleep in my hand till we have built Jerusalem*." Halfway through, I pause. The emotion is too strong, and I fear my voice may break. This I take as a good sign in my teaching. I have shared something deep, sparked by the poem of William Blake. Something about the heart and the hand and a mystical calling and *God working a purpose out in me*.

I have a conversation with Tom Hill, one of the high-profile art collectors in New York. He was my college roommate, has an extraordinary set of paintings and bronzes, and I keep trying to close a deal and sell him a sculpture. He's a very tough negotiator, a legendary Wall Street veteran, whose rule is "I like to get my bait back." We banter about his beautiful David Smith sculpture, which he traded away, swapped for a Francis Bacon painting. He kept his small Gonzalez sculpture. I chide him about how important the conversation was between the two sculptures in the collection. Now the Gonzalez seems a little sad and small, missing the way its destiny was enhanced and realized by Smith. The essence of culture is the dialogue across the centuries as we borrow, adapt, and reconfigure. *Our greatest privilege as artists is to be in conversation with the artists of the past.* Picasso borrowed from Gonzalez the technique of welding. Smith borrowed from Picasso in a more expansive way, bringing to sculpture his versatility, his American know-how and hands-on energy. My view of art collections favors the cultural story and the teaching view. Tom's strategy is different, and his collection is now worth an immense fortune. We talk about how parenting daughters compares with parenting sons. I notice beneath his armored demeanor and impeccably tailored suits that he takes a great sanguine pleasure in being himself, which is the most valuable pleasure of all.

December 2002

One afternoon when the low winter light is beginning to fade, I pause from my studio work, as the day seems to be asking me a question. *What now? What next? What is it that I need?* All my long ambition and grand projects and endless striving fall away. Can anything matter more than a quiet moment of emotional clarity on a darkening December afternoon in flat gray light? It's a key moment when I sense my soul is talking. Other moments in the history of the world matter not at all. This moment matters, my chance *to be here now*, and this awakens a clear view of gratitude and gladness of heart.

Mary and I celebrate out thirtieth wedding anniversary with a big gathering of family. We drive late one night to a large campsite in Zion Canyon, Utah. I could sense the vastness of the granite walls around and above us, barely visible in the starlight. I was reminded of something ineffable, something called the *numinous* that is on the other side of all religions. It is the *shalom* or *the peace that passes understanding*, full of majesty and silence. When we awaken at dawn, the canyon walls soar and loom like something from Chartres Cathedral or the temples of Angkor Wat. The smell of the dank earth under the soaring trees seemed like a primeval life force, the duende, going back to the emptiness at the dawn of the world. A bright-red cardinal on a low branch gives a long, liquid whistle, as if to trill an *alleluia* for the new day dawning.

Murray Dewart

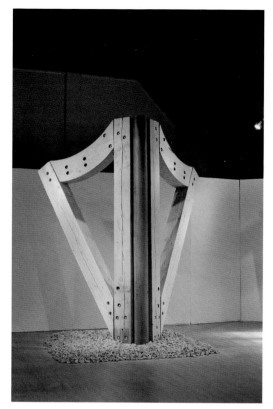

January 2003

The invasion of Iraq, ramped up by President Bush after 9/11, explodes and the drama of it occupies every television screen in every corner of America. I have a nightmare where the war is beginning, the enemy is loitering close by, and I flee deep into the woods. In my Sculpture and Ritual class, we reenact the death of a soldier. We pretend a hand grenade rolls into the assembled group. Who will fall on it? Who has the capacity for self-sacrifice? It's red-headed Christina who falls on the grenade and feigns being dead. We carry her body out and give her a military funeral with a folded flag and taps. There is a riveting silence at the close of the class, and I see that the teaching has gone deep.

I watch the movie *The Pianist*. After witnessing every appalling act of Nazi atrocity, the pianist plays a beautiful piece of music from Mozart. Is such a thing possible? Can I really believe in that redemptive power of art? I call my cousin Julia Randall to talk through this. She holds to a view of art shaped by Mozart and Yeats, who knew about the "blood-dimmed tide." She shares with me a Jack Gilbert poem, set at the door of a Nazi gas chamber. One of the guards decides he wants to die too, but the women push

25

him out, saying no, *that he must live*. Then they sing hymns together, after the door is locked shut.

I had a neighbor named Anna, red-headed, about nine, with a long braid. "Where did you get the red hair?" I asked. "I got my red hair from my grandmother Bessie," Anna said with a proud smile. "But she died in the Holocaust." Then she skipped away, smiling very proudly, her red braid her badge of family honor.

My old friend Mike Schiffer comes for a visit, and we talk for two straight days. Picasso said about his friend and colleague Braque that they were like mountain climbers roped together, and I feel that way about Mike. We've been sharing strategies and talking about art since we were twenty years old. Mike wrote the screenplays for seven major movies, some of them great blockbusters, epic films like *Crimson Tide*, along with two

novels. We have had to reinvent ourselves year in and year out, grappling with the art world and the movie business. On the wall of his Venice office is a sign: "The art world and the film business are like one shallow money trench, a long hallway where thieves and pimps run free, and where good men and good women die like dogs."

Mike and I share a certain combative stance. We pretend there's a Sanskrit word meaning "*artists hurling themselves at the world.*" Mike introduced me to his daughter as the only person more intense than he was. In 1969, we would walk the hills of Vermont on weekends, then go back to Cambridge for antiwar demonstrations, full of fire and declamation. We share something of *a poor boy* stance, going on scholarships to fancy schools. Mike likes to say, "I'm a kid from Philly." We had beat-up, junk cars in our youth, trying to put the moves on classy girlfriends. I had a '52 MG with sketchy brakes and then an Austin Healey with no reverse. I was keen on Lauren, a poetic soul who lived in the Dakota Building on Central Park West and whose family seemed to own most of Philadelphia. Daphne was a willowy cousin of Jackie Kennedy, and Mike was in love with her, though she was less sure about him. These romances were doomed by a core asymmetry, and the humor of this makes its way into Mike's screenplay *Girls Love Cadillacs.* Lauren and Daphne were looking for husbands who had money but didn't care about money. Artists rarely have money and burden their art form if they obsess about this too much. Hollywood is a deadly crucible for artists and writers because purity and authenticity of vision mean nothing. Mike and I have dinner in Harvard Square, and we pass a musician on the street playing a saxophone. We put money into his hat because you can tell he's a great musician. There is a purity and authenticity to the notes. He is a fine artist and he is a beggar.

Mary and I go to a dinner in the South End, and Jane Goodall is there. She is a vivid presence in a red sweater, and I notice she's most like an older version of Mary, vital and engaging. I share with her Camus's observation that the secret to happiness is working outside. "Yes," she says, "That's true. But more importantly," and here she looked powerfully at me with her riveting eyes and said, "being at home in yourself." The eye contact is strong and the message clear and unforgettable. I remember as a teenager seeing her picture in *National Geographic* and thinking *that's the kind of woman I want to marry.* And lo and behold, it came true.

My friend Jep comes for dinner. He has a puckish, energetic imagination and an intensity that matches my own. I asked him once if he ever tried being less intense. He tried, he said, and it worked for about twenty minutes. There is a crisis at the Episcopal Cathedral where he serves as dean. Bishop Tom Shaw is impatient with the place not becoming the flagship of the diocese. A crew of masons were preparing the brick entryway to the cathedral, and they are slow in their work. The annual convention was about to begin in a week. Bishop Shaw, a short man wearing a windbreaker, asked the lead

mason a second time when the work would be done. "Who the fuck are you and what's it to you?" he bellowed. Inside the cathedral, the Most Reverend Thomas Shaw, SSJE, was in a blistering rage, directing his anger at Jep. We talk through this at dinner. It's rare for men to share their setbacks, but my dinner invitation to Jep opened the door.

My assistant Ryan shows up for work with a chipped tooth after cracking it in a skateboard accident. Right away I take him up Beacon Street to my dentist to have it repaired. I never felt better about spending two hundred dollars, which I remember every time he smiles.

Murray Dewart

March 2003

I am happy when two new projects roll into view, another park sculpture for a city in China, and an entire park in Cambridge. Mary, Nate, and Solana, his girlfriend, join me for a site visit. It's a beat-up pocket park, entirely concrete, used by drug dealers, and the City of Cambridge has a big budget to transform it. Mary has years of design experience and we put it to use, planning a curved pathway and raised planting beds. Hafthor, the director of public art for Cambridge, wants a wooden gateway, but I carefully talk him out of it, knowing that granite will better serve our purpose. The money rolls in and I place a big order for granite in Barre, Vermont. While I am at it, I dream up the idea for a turned granite bollard form with words carved into the bands:
AWAKEN SEED SING PSALM SUN ACORN ORCHID BLOSSOM DAUGHTER MOON MOTHER HAWK SALMON SON STAR FATHER LILY TIGER SLEEP

March 2003

I inherited my father's massive rolltop desk, which he inherited from a doctor in St. Johnsbury, Vermont. I thought about that sequence from doctor to priest to sculptor one day when I was called and asked to make a death mask, once a common practice in Europe. First the doctor does all she can, then calls for the priest and for last rites. Then the sculptor arrives with his plaster and tools to capture a face still warm but growing cold. We have this reluctance to vanish, so readily, into the air. Sculptors have answered the call since the beginning of time. I never did make the mask, I am relieved to say. Sculpture, as a medium, must always fight against the *deadness of being a thing*, an inanimate thing, as the critic Pater observed. With all our sculptor's knowledge about materials, our tricks and techniques, we're always circling back to a *way of incantation, incanting the life-force*, the subtle, twinkling life that bounces off the cold bronze or stone or steel form. We pour in all our energy and time and use up our stamina and wear out our eyes and our hands and our backs on the chance that the forms will come to life, that some sparking fire will keep burning in the stone-cold form long after we are gone.

June 2003

Another fax at three o'clock in the morning from China wakes me up with the question "What sculpture will you build in Fuzhou?" I decide on a sculpture I call *Earth House Hold*, named for a book by Gary Snyder, who did translations from Chinese poetry and is responsible for much of the East-West dialogue. The sculpture seems an emblem of family, a linked family under one roof. I do a life-size drawing to send to China and hire a team of assistants to help with the Cambridge park. How will it all get completed?

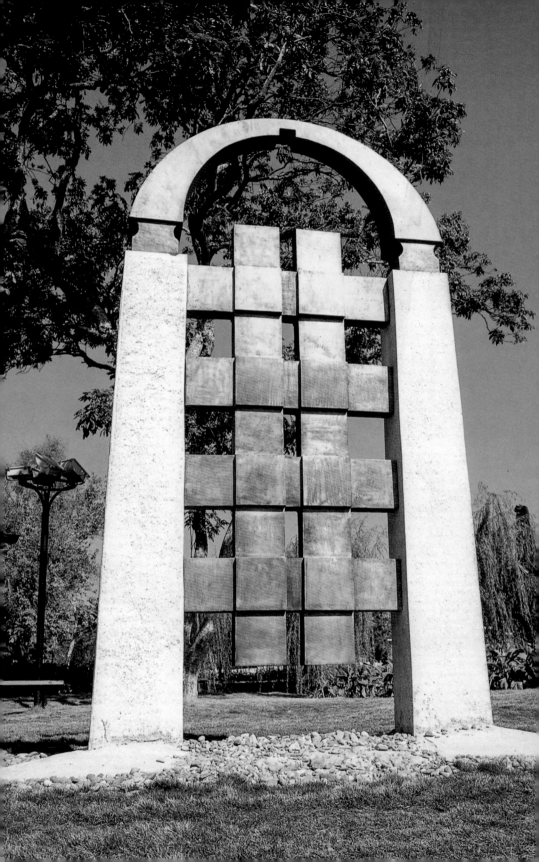

Meanwhile my big bronze, the Fuller commission called *Sun Gate*, has permanently stalled. I keep the sculpture and the down payment and the deeply bruised feelings. I deliver the piece to a show at the Chesterwood Museum in western Massachusetts. At the Cambridge park, a pair of three-ton columns is set in place with a big crane. We install a ductile iron fence. Each section, cast in a foundry, is made from five of my maquettes. There's a huge bronze top for the gate that I weld up in the Everett studio. The weight is massive, and the bottom welds keep cracking. As I am preparing to leave for China, I learn my request for a one-week leave of absence from my Brookline teaching job has been denied. I need to shorten my China trip and wonder how in the world everything will ever be completed. Facing deadlines, I race across the city, trying not to go over budget, trying to replace a broken welding tip, then misplace my cell phone. I am feeling a little crazed. Then Hafthor calls and wants the rear wall sculpture installed by the end of the week. Each night I lie down in complete and utter exhaustion.

July 2003

One day in the Cambridge park, as I was standing on a ladder, Philip Fisher and Elaine Scarry stop to talk. They are a star couple on the Harvard faculty, highly original, with dazzling intellects. Elaine has a great flower garden in their house close by the park. *On Beauty and Being Just* is one of Elaine's books that I always assign my sculpture classes. We converse about an Emily Dickinson poem, about lilac blossoms, and Plato's concept of the highest good. There's a graciousness I notice in their dynamic as a couple, an affirming reciprocity, that's highly evolved and inspiring.

August 2003

When I fly into Fuzhou, I am greeted by a translator, a professor, and a girl carrying flowers. My twelve-foot-high bronze and granite sculpture will have a beautiful site on the bend of a river park. In the cool air at dawn, I walk the city streets, looking for a good cup of coffee, to no avail. A young woman with a ponytail is sweeping the sidewalk with a reed broom and moves like a dancer, a youth is whistling a melody on a bike piled high with cardboard boxes, an elderly man does tai chi by the stone dragons of a gateway. By ten in the morning, our worksite is sweltering hot. The big-bladed electric saws, cooled by water, cut the granite and it goes slowly. We get a safety talk, Chinese style and not reassuring. If you are being electrocuted, put your arms straight up in the air so the electric current misses your heart. Among the European artists, there is an undercurrent of resentment about the invasion of Iraq. The Czech sculptor Jiri, fiercely anti-American, harangues me relentlessly about George Bush and his missiles. Nothing I say can quell his Czech fury. Later my Boston friend Peter Haines, working on a

marble carving near me, badly cuts his foot with an angle grinder. We race him in a van to the hospital, which is grim and blood-splattered, like something out of Dante's Inferno. When they learn he is an American, everything improves and a spotless room is found. Peter was a Marine captain in Vietnam and is not in the slightest bit fazed.

Some nights all the sculptors gather for a drawing session with brushes, pots of ink, and piles of rice paper. There's lots of shouting and hooting as our shared language as artists is made manifest. Birds, beasts, flowers, nudes, line, shadow, wash, and endless inventions of form. I speak no Chinese and the sculptors around me speak no English, but we roar with laughter at what our brushes can express.

The organizing committee gives me a Chinese name. It is carved onto a stone tool so I can sign my drawings in Chinese. It seems to mean "pilgrim or seeker after the holy." They send me to a sleepy temple pagoda with a young translator. I tell her to watch how the sunlight and the shadows change, moving ever so slowly across the tile floor. There is an ancient tree directly in the path of the temple doorway that requires deference, in a ritual way, to the natural world, to the god who breathes the day awake.

As I am preparing to leave China, our plane fills with passengers while music plays, a Chinese melody on a stringed instrument. Perhaps it's my exhaustion, but something powerfully evocative occurs, as one person after another moves into the cabin. *I seem to know every face from another lifetime, a partial recognition, people I've known long ago.* It's like a reverie out of Homer or a Hollywood retrospective. Music is a power medium, and it transforms the moment into a theatrical tableau and I am almost in tears. All this humanity is about to hurtle across the sky into the unknowable future. It's a procession of souls, maybe kindred souls, the ones that Moses led, that the Buddha awoke, that Jesus wept for. Why do I feel this prayerful moment as the airplane taxis for takeoff? Something about being mortal? I remember Rabbi Hillel's injunction:

If I am not for myself, who will be for me?
If I am for myself alone, what am I?

September 2003

One of my best clients calls, wanting another big horse sculpture for a racetrack in Saratoga, New York. An earlier commission of his in 1993, *Pegasus Arch*, twenty feet high, went to an office park in Scranton, and I periodically go to Google Maps to see if it needs repainting. I love the sculpture's raw forthrightness, thick one-inch plate steel rolled into parabolic curves. The winged horse, emblem of poetry, is painted an in-

tense blue in keeping with Mallarmé and the French obsession with *l'azure*. So that's its artiness, but it's also a rough and ready steel piece that seems straight-ahead American energy, a fitting sculpture for hardscrabble Scranton. I travel upstate to the New York racetrack, then go to the Everett studio and draw up a plan for building something big. There are some huge curved steel pipes in McGarry's back storage that might work. Not that I want to deal with the dangerous and hot-headed McGarry.

I read a biography of E.E. Cummings. I find something difficult, even repugnant, about him, his bigotry and anti-Semitism, his spoiled, adolescent, and mannered punctuation. He never held any kind of a job until Harvard appointed him the Norton Lecturer for a year. Artists almost always struggle with the issue of gainful employment, and if it doesn't ruin us, it deepens us. I think of the artists I most admire: Henry Moore, David Smith, Barbara Hepworth, Isamu Noguchi, Mark di Suvero. They sometimes taught, sometimes worked in factories, as I have done. To be authentic and to make the sculptures that you want to make requires being diligent and clever. Some day jobs can take the marrow right out of your bones, and these are to be avoided.

October 2003

It's a fulcrum moment of the year, and in New England there's the hurry-up call of the turning autumn trees. I phone my sons from outside Fenway Park as the Red Sox beat the Oakland A's in a close game and pennant fever sweeps Boston. A letter arrives from Peter Haines in China, and, amazingly, its official Chinese stamp has a picture of my Fuzhou sculpture. The first snowfall comes as I watch from the studio loft, big wet flakes falling on the gold and yellow leaves as harried sparrows wheel to and fro, as if to say "too soon, too soon." The sky is lightening but I am dreading the onset of winter, remembering lines of Wallace Stevens:

Passions of rain, or moods in falling snow
Grievings in loneliness . . . gusty emotions on wet roads on autumn nights

There're hints of blue beyond the scudding clouds, and I am trying not to go autumnal in mood. I am fifty-five years old, the age my grandfather died. The snowflakes change to water on the surface of the skylight, a magical change of matter as I work at a magical change of spirit in my soul. The *Sun Gate* sculpture is returned from the Chesterwood Museum, and with my assistant Ryan we muscle it back into the studio and fasten it to a steel base. It haunts me with its beauty and largeness of spirit. At the Chesterwood Museum, it seemed grand and perfectly scaled. I am feeling bruised by the client's rejection, and it pains me that I'm still having to obsess about its fate and destiny as a massive half-ton object.

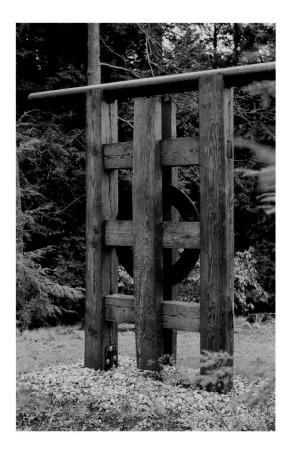

Teaching in a Catholic college, I have grown used to the odd fact that there is a crucifix on the wall of every classroom. Then I noticed a recurring dream where I am driving around in my truck with the body of Christ in the back, under a pile of winter coats. I tried talking about it to a priest, then a psychiatrist. Finally a rabbi said to me, "After a dream like that, you need to run naked into the sea at dawn. Do that three times." It worked like a charm. I never had the dream again.

November 2003

Albert Alcalay, a wonderful painter and one of my teachers at Harvard, is in his eighties and cleaning out his basement. He gives me three old sculptures by Mirko Basaldella, his close Italian friend who ran the Visual Studies Program at Harvard in the Carpenter Center's Corbusier Building. One of the sculptures is a Styrofoam totem figure that Mirko never finished casting in bronze. It is ten feet high and I carry it home on my

shoulder the four blocks from Albert's house. Mirko had been a reigning presence at the Carpenter Center. His studio was on the top floor, and the shops had big Italian bandsaws useful for the kind of assemblages he made. He was a heavy smoker, and in 1969, dancing at a party with his wife, Serena, he had a massive coronary and died. The faculty and students were devastated. Mirko's sculptures loomed all around the building. Like Henry Moore's, Mirko's figures were partly surreal, partly Mayan, partly classical in the manner of modernist Europeans. Albert described Mirko's sculptures as "figures from a religion that does not exist." As an eager student just beginning, I absorbed this in the deepest way as it resonated with a core aspect of my imagination. I was hungry for the sacramental dimension of sculptural form. Mirko tapped something mythic, and as I carried his totem sculpture home, I felt like a tribal shaman with a fertility god or goddess, calling down rain for the village cropland.

There's always been for me the riddle of whether I can be a good artist and a good human being at the same time. At the Carpenter Center, a documentary film about Alcalay was shown. He was Jewish and needed to flee Hungary, then was imprisoned in a Nazi camp in Italy, where they broke his hands because they knew he was an artist. In the movie, he was describing his sense of his life's purpose, that God was working a purpose out in him, though he hesitated to use the word "God." "I am not a religious person, but there was some kind of redemption," he said, "some invisible force pushing me, prodding me." Then he burst into tears and sobbed, "*To be a good person!*" I was touched and always inspired by him, so genuine, spirited, and emotional a soul, who listened to the *St. Matthew Passion* of Bach everyday on the way to his studio.

Albert's paintings changed after the death of his close friend Mirko. Before, they were abstract and flat with a bird's-eye perspective. He described how his grief at losing Mirko caused him to pound and slap the canvases with his brushes, over and over, until suddenly the horizon line came back into view. He became in that instant a landscape painter looking at the world as Monet and Matisse had done before him.

By happenstance, a call goes out from a group at Harvard for outdoor sculptures, and I leap at this, bringing *Sun Gate* to Leverett House on Memorial Drive by the river. I site the sculpture squarely in the middle of the big courtyard. Its Apollonian symmetry echoes the classicism of the Georgian architecture, and it seems to look at home. To the widely international student body, it offers a welcoming gesture and salute. The house master and his wife show a keen interest. There are articles in the Harvard newspapers. I am quoted: "As artists we give the world metaphors. When the sculptures are good, they have a kind of life, *the life that is fluent in even the wintriest bronze. Sun Gate* will stay in the maw of the world long into the future." At dinner, Peter Haines and I brainstorm a proposal: Yo-Yo Ma and I will go talk to the new Harvard president about strengthening the arts curriculum at long last.

Hammer and Tongs

December 2003

I've had a long siege of illness, a hacking cough and recurring fever for weeks. A big family crowd with Nate and Solana come for Christmas dinner at the long plank table in the studio. After dessert, I climb up into the studio loft and fall asleep. My grandfather died at fifty-five, and I wonder if this is a psychosomatic ailment. The doctor advises another week of bed rest, and Mary makes me chicken soup the old-fashioned way. She has had to encounter my bearish, lumbering self, clouded, out of focus, and out of touch. I write a birthday letter to Caleb as he prepares for the birth of his first child. It's a hovering spirit, an old soul approaching out of the dark. He and Lisa like the name Clare, my mother's name, so I give her a call at the nursing home where she hovers at the other edge of life, sounding breathless and a little frail on the phone.

March 2004

A new project emerges for a New York casino, which has a generous budget. Mary and I plan a renovation for the downstairs of our old Victorian house on a big lot, one mile from the absolute center of Boston. We are planning a space to live out our days. Will it be in loving kindness to each other? We quoted the poet Rilke in our wedding vows, the line about "*the two solitudes that border, protect, and salute each other.*" This has grown irksome to Mary as a concept, as she wants intimacy, not more solitude. We have flare-ups and disagreements, but they don't seem to last. We are constantly at work fine-tuning our dynamic. I see this as a polishing strategy, each year changing to a finer and finer grit of sandpaper. I want the light to bounce off us as a couple, but I don't want to delude myself. If I seem deaf to her entreaties, maybe a hearing aid is needed. The money from my teaching jobs and Mary's landscape design business keeps our quotidian boat on an even keel. What did Flaubert say: *Be a revolutionary in your art form but bourgeois in your daily life?*

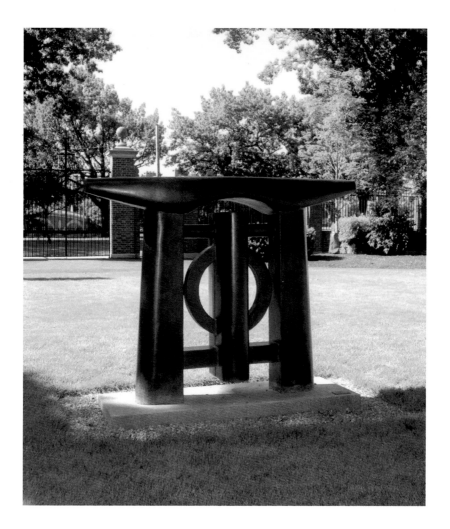

In a Quincy granite yard, I find some six-ton sections of columns from the old Suffolk County courthouse that were dumped under the Tobin Bridge by Boston Harbor. Excavated out of the mud, they have a magnificent, beat-up grandeur, the fluting marred and broken like the Parthenon columns lying on the ground, and I buy them for very short money. I make a plan to cut them in half with a wire saw in Barre. I plan a low Buddhist gate, look around for a granite lintel, and broach the idea with various architects.

In *Sculpture Magazine* there is an article about my Cambridge park, in which a museum curator talks about the "*signature pieces in Dewart's mature style.*" I have found my own particular language of form as one sculpture slowly follows another. I obsess

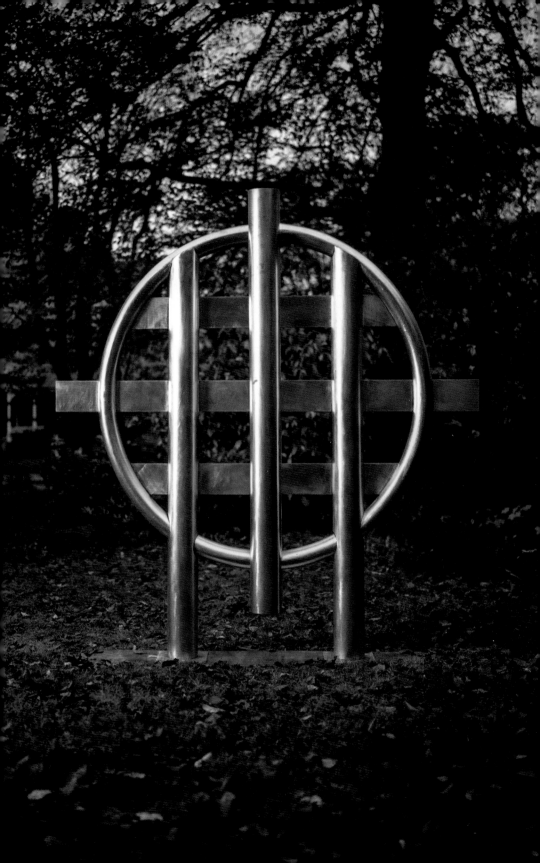

over the proportions of everything, the amount of taper in the columns, the ratio of open form to closed form. I repeat certain elements in sand-cast bronze to save money, building sculptures before a client is at hand. I seem to have arrived at a form that viewers identify as uniquely mine. This accomplishment is born of a strong need. Peter Schjeldahl, art critic for the *New Yorker*, writes that "the proof of any work's lasting value is a comprehensive, emotional need. A person had to make this, and it awakens and satisfies in the viewer a corresponding need." For public sculptures juried by a committee, this is nearly impossible and rarely occurs. It is why public sculptures are often mediocre and prosaic accomplishments.

Occasional clients stop in as I work up a new set of sculptures, feeling my way along with their proportions. There has been a loaf of challah bread on my workbench for two years, dried and stale, but something in the form was compelling. A strict Jewish bakery sells challah only on Friday. I kept sensing lovers in the yeast-inflated form, and something both labial and phallic. With Ryan's help, I carve this into a wood pattern that goes to the sand-casting foundry. The bronze elements hold in place a dozen river stones, and I call the sculpture *Sabbath Loaf*. It becomes a popular piece, an edition of eight, sometimes with a black patina, sometimes blue green.

The last day of March we visit our accountant, who more than anyone knows the facts of our life. He sees me in dusty workman's clothes, a careless bookkeeper, a storyteller talking elliptically about philosophy and poems. With an amused smile, he tolerates my absentmindedness. Selling sculpture is not like running an auto-parts store. "Double your prices," he always says, which was my father's advice, but I know from experience that will not work.

April 2004

For my casino project, I need to truck one ton of thick maple and cherry boards from the lumberyard into the city. On the highway in Charlestown, I nearly lose the whole load as it starts to slide into the roadway. I am furious with myself for the danger I have risked. Chains, tie-downs, safety straps! Why can't I learn? Jep has noticed that I am a novel combination of dreaminess and practicality, which sounds like a dangerous mix. When things go wrong in sculpture, it generally involves weight. It's an ever-present danger. The great Mark di Suvero walks with a limp. Beverly Pepper and Richard Serra had accidents with their assistants killed by falling steel. David Smith died in his van when it skidded off the road and the steel he was carrying crushed him.

The earth is warming, the trees are budding, but the news from Iraq is a constant tragic distraction. The American occupation appears as a giant error, and the Bush administration's incompetence is manifestly clear. I write an op-ed piece for the *Times*, but it doesn't make the cut. I head into the mountains to gather river stones for my new sculpture project. It's a bright spring morning. I feel close to the central mystery of the world as I walk in the shallow riverbed, searching for the perfect stones, rounded smooth, scrubbed clean in the fast mountain current. It's exhausting work, lugging heavy granite half a mile back to my truck. Alone on the river, I talk out loud to the stones: "Oh, look at you. You're a beauty." All morning I've had the feeling of being in love with my life, happy to be such a strange pilgrim gathering stones this way. Sometimes as artists we self-identify as "holy idiots," and my time on the river is one of those. I go to lunch in

a roadhouse and call Caleb in Los Angeles, checking on the baby about to be born. On the way home, I stop in Concord and walk around Walden Pond. I think about the truth Thoreau lived, complicated, questing, sometimes querulous, but always authentic. Keats said that great artists live a parable, and their work is a comment on it. Keats was thinking about Shakespeare in this. Important work grows from a deep place in a life. It is more than the dexterity of the hand, more than fluency, braininess, or wit. Keats's favorite Shakespeare was *King Lear*, which he read over and over. His quest as a poet was for nothing less than the moral order of the universe.

Something from the Easter season has triggered a dream where I meet my old friend Philip Coolidge come back to life. He was a brilliant classmate, very gifted as a writer and very idealistic, bringing water projects to the poorest parts of Africa when he died suddenly in the Cape Verde Islands of pneumonia at the age of thirty-three. In the dream, he is twenty years old, and I am puzzled. How did he stay in Africa all those years? How has he not aged? I raised money for a scholarship fund at Milton Academy named for him. Waking, I remember I should go call on his mother, Rosina. With several classmates, I pay her a visit. She has trouble locating a picture of him. Her days are filled attending to her daughters and a raft of grandchildren, and her memory of Philip has grown dim. Why do we as classmates still carry around an elaborate heart-shrine? What is our need? We have idealized him, recalling how he sang *Jerusalem* with all of us, years ago at chapel. We might say that the Islands of Cape Verde are a little greener and more pleasant because of Philip Coolidge. We might say that fewer will have suffered, or fewer will have died. Or we might say, most simply of all, that *it was Jerusalem he was building there. Jerusalem.*

June 2004

Mary's garden is lush and green, and I remember being nine when my family moved to this Brookline neighborhood full of trees and lawns. The rectory where we lived was a great stone house surrounded by a garden. I had never smelled freshly cut grass. We left the rough blue-collar neighborhood of Everett, where the yards were mostly concrete, with an occasional olive tree or rosebush. I still have within me my *poor-boy story* from Everett, working on a coal truck at seven, wandering alone by the railroad tracks, then going to fancy schools on scholarships, wearing hand-me-down clothes and trying to fit in. It helps to have an egalitarian bias in American life, so long as it's not a chip on your shoulder, a tiresome chip. A natural piece of all clergy families is advanced expectations but little money to help implement them, and I have been OK with that.

For many years, my parents kept in their backyard a large early carving of mine with lots of forthright sexuality. It delighted my father, who also kept a large picture of Mi-

chelangelo's *David* in his study. Sex and religion can be a complicated mix, but it didn't seem to bother my father. He had a wide range of tastes and enjoyed reading Joyce, D.H. Lawrence, and later Susan Sontag. In her journals, she wrote forthrightly about the relation of orgasm to her art. "The orgasm focuses. I lust to write. The coming of the orgasm is not the salvation but the birth of my ego. I cannot write until I find my ego. Before I had them, my sexuality was horizontal, an infinite line capable of being infinitely subdivided. Now it is vertical, it is up and over, or it is nothing." John Cheever also wrote about the relationship of orgasm to art. "My body is wracked by orgasm. Why can't my art do the same?"

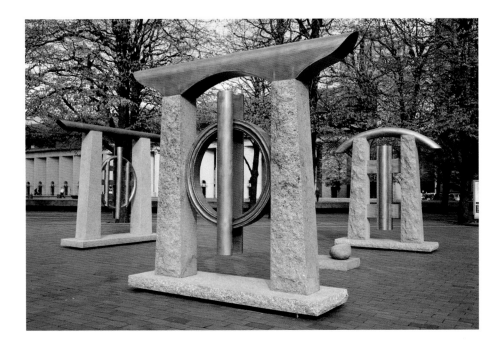

June 2004

The presidential race heats up, and the anti-Bush sentiment is strong in Massachusetts. Mary and I rent a large bus and corral a group of friends to join us in N.H. canvassing for John Kerry, running against Bush. In a parking lot, I find a truck with an anti-Kerry bumper sticker, a peace sign, and the words *Footprint of an American Chicken*. I wait around in a fit of pique, wanting to meet the owner and provoke a confrontation.

June 2004

Phil Fisher comes for lunch, and I show him the renovation. "How will you and Mary fill this space with your life?" he asks. He is relaxed, amused, engaging, ebullient, sardonic, still the most brilliant intellect I have ever encountered. He was my tutor in 1968, and as an English major I spent one afternoon a week in deep conversations with him about language, philosophy, history, Joyce, Wordsworth, Eliot, and Rilke. His intellect could direct a laser light into the heart of everything: art, religion, politics, human motivation. As an intellectual of the very first rank, he is razor-sharp in dismissing cant and liberal pieties. He has little sympathy with the posturing of many artists. I made a plan to drop my senior thesis and spend my last year at Harvard making sculpture. He advised me not to, but I went against his advice, not an easy thing to do. He grew up in a big Catholic family in Pittsburgh and has a jaundiced and visceral reservation about religion. I asked him to be a godfather for Nathaniel and he agreed. We talk about his newest book, *The Vehement Passions*. I say, "You were pretty hard on Pascal and John Donne." We never argue and mainly I listen, because there's always a novelty and clarity and kindness to his thought.

June

My Saratoga horse project has hit a snag as the client, Daniel Gerrity, wants a realistic horse, but I am not inclined anymore to have my name attached to such a sculpture. I could be the middle-man broker for a Chinese sculptor, but that's a huge amount of work with little gain for me. Instead, Daniel decides to buy my eight-foot-high *Kyrie*, a copper piece with a high shine and one of my best, for an office building near Boston, where it barely clears the doorway as we ramp it in.

Jep and a group of us go to see *Fahrenheit 9/11*, a movie about the Iraq invasion. The bombing of Baghdad with the thudding, billowing fire reawakens an old trauma, and we stand in silence as the theater empties. What to say? What to do? I plan for a sculpture I am calling *Liberty Bell*. I have made a cast from a nineteenth-century bell, which I then split in half. At the center is a text of the Bill of Rights in five languages scrolled into five bronze tubes.

July 2004

The bombing campaign in Iraq brings to mind the wreckage I found of a bomber, a B-17 from World War II, high up in the Green Mountains on a spring hike when Caleb and Nathaniel were still young. A man from the village had said it was there, high on

the ridge, two miles from the gravel road. We began as if on a treasure hunt, with a scribbled map and a notation about a giant white birch tree. I had a clear picture of all those vintage planes, the wing markings and the gun turrets, left from the toys and the model planes of my boyhood. This B-17, so the story went, had lost its way one stormy night, returning from a submarine patrol, the war with Germany and Japan barely four weeks old. Some of the airmen died in the crash, some staggered away, crawling through drifted snow toward the lights in the village below. In a stand of birch trees by a brook, I stumbled on one engine almost by chance, then found a door, a crumpled wing. There was little that remained: pods of molten metal, a splintered shaft embedded in an ancient tree, broken glass, one wing insignia filled with the graffiti of passing hunters. I had expected more drama, I suppose, a sudden chorus of Beethoven or Yeats. The great silver bird of my imagining lay simply as trash, all but lost to the forest floor. As we turned to go, one of my sons picked up a bird's nest, an oriole's, we thought, fallen from a nearby tree. The bird had included in her customary weave of bark and twig shreds of fabric from the aircraft seat. It was a curious kind of memorial wreath woven as it was for the future, for her young, to warm and to cradle their bodies with the very fragments from this ruin. She looked to the future's promise, hopeful, weaving in her instinctive and unconscious way this fragile crown, as her prayer and her prophecy.

An article appears in *Landscape Architecture Magazine* with strong praise for my Cambridge park. I am called one of *Boston's premier sculptors making world-class pieces.* In the art world, these turns of phrase are *coin of the realm*, worth their weight in gold, and they will appear in my press releases for the next decade.

I have one of my recurring Vermont dreams where Mary and I are walking the farm fields and crowds gather to hear us. We are introduced to various groups, and a young carpenter comes forward with scars on his hands. I peer into his face, trying to remember him. Waking, I parse the dream, which felt reminiscent of my time in China. I have become a public person, engaging with group after group. In Fuzhou, a soldier from the security detail said to my translator that he saw kindness in my face. In a foreign country, where you don't share the language, your face must be the expressive and communicative tool. I try to remember the face of the young carpenter with scarred hands and ponder the Christlike sense of him. Wallace Stevens writes:

> *What is divinity if it can come*
> *Only in silent shadows and in dreams?*

On the phone with Caleb, I talk through the details of the coming birth and how to be present with a wife in labor. I had two chances with this and learned from my first mistake, as he was making his way into the world. Mary's labor had been long, that winter day in Burlington, Vermont, and I had wandered into a long conversation with the doctor about woodchucks, and how to hunt them with various-caliber rifles. This was idiotic of me and nearly unforgivable. Atonement occurred at Nathaniel's birth, when I gave laser focus to every contraction that Mary had.

July

At an eighteenth-century farmhouse under arching maple trees, Mary and I attend the wedding of Jep and Sue, a second marriage for both. As the vows are being said, Sue's face registers something of the past, for she had nursed a dying husband for five years. It also registers the future and the challenges that await her with Jep. We do not need to know or want to know the future. We need to guard the bonds of love that give us the courage to face what lies ahead. Jep was a friend and colleague of my father and is an Episcopal priest in the same mold. My father's worn-out prayer book is in a drawer where I keep old broken tools, and it looks at home there. The binding is darkened

by the oil from his hands, and the pages are torn and water-stained from graveside funerals in the rain. It is a book worn out attending the basic mysteries of life: weddings, births, sickness, and death. The clergy understand the privilege and the burden of standing at the center of all things and being witness.

July 2004

I have a sculpture going to a law firm in Times Square, and I need to measure the site. Riding the train to New York, I get a window seat and take in all the details of the landscape as it rolls past: lush, coastal estuaries alternating with the sad underbellies of abandoned mill towns. I think to myself: *How can I love this world, such as it is?* Old stone walls, a weathered hay barn and a lone horse, a swollen river, a storefront church, mist rising from a pond, then detritus and debris, ash pits, overturned cars and rusted machinery, everywhere blight, graffiti, and the night work of fatherless boys. It is twilight, the hour the Scots call *the gloaming*, and suddenly there's a pond where swans are idling near a darkening wood. Mile after mile, it's a landscape of brokenness and grandeur, the restless American story of building and breaking, energetic, hopeful, careless, and then moving on. Near Brooklyn, through a kitchen window, I get a sudden glimpse of a Sabbath ritual where menorah candles are being lighted. It's Friday night and a family is sitting down to eat, their heads bowed in prayer, a prayer that reaches me and touches me, as the train thunders past.

For my return home, I am waiting in the New York train station when a waitress notices that I'm writing and sketching in my notebook. She's an artist herself, she says, and sometimes *we let the word be the deed*. We have a talk about the imagination, how artists give the world metaphors, as if following the plow of their own invention. I share the story of my daily commute to a big industrial studio, driving with Mozart operas blaring and an inspection sticker lapsed for more than a year. When a policeman noticed and gave me a ticket, I had to thank him for protecting me from myself. Being an artist is no excuse for anything, try as we might to make it so. Some call us "*the holy idiots*," sometimes starving and a little crazy. "Some artists," I say, "live a parable and their work is a comment on it." The waitress smiles a twinkling smile and asks, "So what's your parable?" Just as I begin to phrase an answer, the boarding call for my train is announced. I grab my bags and begin to leave, then pause, baffled by my need to answer her, as she polishes a wine glass. "*I am a pilgrim-builder . . . and I am on the road to Jerusalem in a way I cannot explain*," I say. I wave her goodbye and race to catch my train.

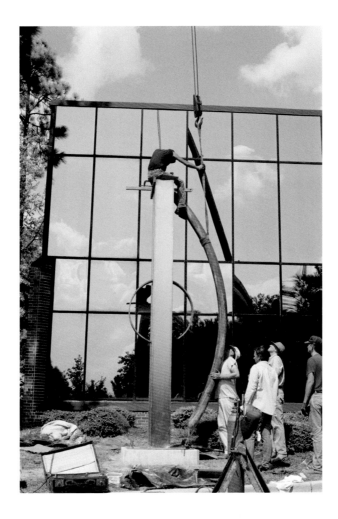

I work big and I work medium-size and I work small. It occurs to me that many of the cities where my big sculptures are installed may be underwater when the sea levels rise. Perhaps my smallest sculptures have the greatest chance of surviving. For my best client, who buys a sculpture from me almost every year, I build a bronze door knocker. I work on a small six-inch version of my fourteen-foot-high Birmingham, Alabama, sculpture, a commission I won in an international competition in 1993. The organization wants to give out the small bronzes every year as an honorarium. I've built the sculpture in half a dozen sizes, in a variety of materials, most notably in a silver brooch two inches long that Mary wears to parties.

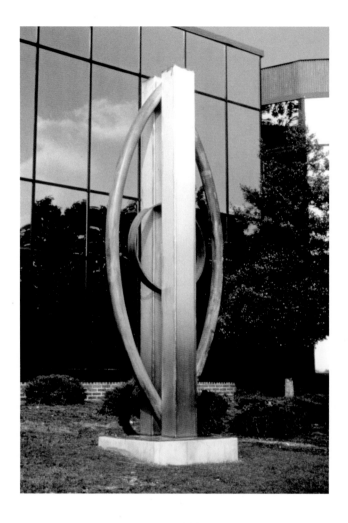

August 2004

Lucy Clare Dewart was born on August 4, our first grandchild, a beautiful bright spirit and bud of consciousness. All four grandparents flew to Los Angeles to welcome her into the world, bringing a cake. She was coddled, cuddled, and rocked. The miracle of new life is powerful. I see something of my late father in her face, and she has something of my mother's auburn hair. We are caught, wrote Yeats, between the immortality of tribe and that of soul. We fly briefly into this world like swallows into a lighted barn, then out again.

Louise Glück has been a favorite of mine since her *Firstborn* volume in 1968. In an essay she writes about the restless yearning behind the artwork:

It seems to me that the desire to make art produces an ongoing experience of longing, a restlessness ... Always there seems something ahead, the next poem or story, visible, at least, apprehensible, but unreachable.

August 2004

I take the ferryboat to Martha's Vineyard and have lunch with Fran and Ernie Wilson, who was another of my college roommates. We had a big suite in Adams House, and Ernie was the head of the African American Students, where his poise and affable presence made him a key player in the tumult of the sixties. The notes on his door read "Call President Pusey back" or "Dean Ford needs you at a meeting." Ernie worked for a time in the Clinton White House on the National Security staff. Celebrity culture is very prominent on the Vineyard, and the Wilsons are in their element, working the crowds. The night before they'd dined with Bill and Hillary Clinton, and they introduce me to Vernon Jordan and Skip Gates. We joke and share the refrain "I am done with social climbing, but a little name-dropping here and there can't hurt." Years earlier I had gone for a visit to James Taylor and Carly Simon's place in Lambert's Cove near Vineyard Haven. Fame, I have noticed, has requirements for symmetry. James sometimes goes sailing with Bill Clinton, and there the symmetry is about right. At fifteen, in the library at Milton Academy, I had tried to talk James out of his plan for leaving school. What would happen to him as a high school dropout? About five years later, he was on the cover of *Time* magazine. So much for my gift of prophecy.

August 2004

In my Everett studio, I weld up the *Kyrie* bronze for Times Square along with my *Sabbath Loaf*, getting the bronze to flow like butter. I need to let the bronze cool, so I go for lunch. Standing in line for a roast beef sandwich in my dusty welder's clothes near my father's old church off Main Street, I reflect upon my station in life. When you love what you are doing, nothing else matters. You can disappear into the discipline of the work and never need to look up. I love making sculpture, and I think my father loved being a pastor, loved walking these poor Everett streets, attending his parish, a church, he said, of three hundred souls.

Hammer and Tongs

September 2004

Peter Haines comes for lunch and gives me grief about some flawed welds on my newest bronze. He is an impeccable craftsman, and I have learned to listen to him, though he never seems to listen to me. He lives four blocks from my Cambridge park but has never stepped foot there. He often laments that he is not famous enough, in the general scheme of things. I share with him a comment from my writer friend Justin, who says, "*If I were more famous, I would be more of an asshole than I already am.*" I offer Peter suggestions, but there's a stubborn resistance and a modesty about changing his methods. There's a solidity about him, likable and stoic, his Marine captain side, gruff but highly moral. We have worked side by side for thirty years and I prize his friendship.

October 2004

We go for a visit to the Bisbee farm in Vermont, high on a hillside above the Mad River valley. At dawn I caught a glimpse of something powerful and epic in the landscape of turning trees. Mary sensed something happening and photographed me sitting on a rock in rapt attention. All the life forms in the rising autumn mist seemed to pulse with one voice. I thought: *God, are you talking to me?* Words came as an afterthought, and what surfaced was the Wordsworth lodged in my bones:

With an eye made quiet by the power of harmony, we see into the life of things.

Then echoes of Neruda, of Elaine Scarry on moral generosity, then Emerson and Eliot. I was conscious of encountering something divine and revelatory, unmediated by scripture. I sensed that I was seeing into *the heart of the world*, or as the Maori say, *the mother who never dies.*

I call my cousin Julia to talk over my vision in the meadow at sunrise. She has many poems that are visionary meditations on the natural world, like one called *The Bennett Springs Road* that we read at our wedding, with these lines:

On the road to Bennett Springs
tired of the paltry ridges I lay down
the last of my youth where all the gods had grown,
became the water falling over the stone,
became the forest father to red men,
became the tribe of stars, both daughter and son,
the mother of moss the bird that sang I am.

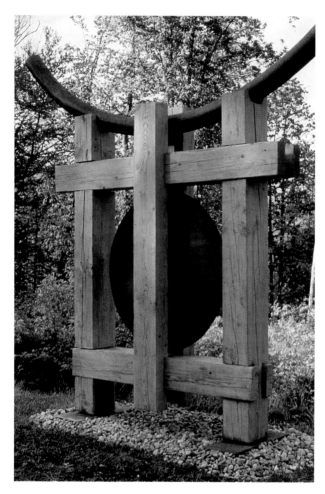

We have a discourse on Plato, Yeats, and Elaine Scarry. She is growing frail but is planning an essay on Wordsworth, whom she loves extravagantly. I talk with her about my plan for a text in my upcoming show called *Late Flower Alphabet*. I ask her if there was something sexual in the Bennett Springs poem, "*laying down the last of my youth.*" She says that's not the case, but I don't believe her.

Pennant fever sweeps Boston as the Sox beat the dreaded Yankees for the division title. John Kerry has a surge in the polls. I wonder where I will go if there's a Bush victory. Maybe we would live in exile in France or Shanghai. How will I square my heart to such a prospect? Nate and Solana come for a visit, and we have a raucous dinner with her MIT roommates, Karen and Lily. These three smart, gifted women are called the Triplets as they cut a distinct profile. Lily is Jewish, Karen is Chinese, and Solana is African

American They represent the cutting edge of the new generation of American women, poised, confident, and empowered.

In the damp October air, the sound from Fenway Park carries the half mile to our house as the Red Sox play the Cardinals in the World Series. The night the Sox clinch the Series, there are helicopters making a racket we can hear all night long above Kenmore Square. The eighty-year drought for the Sox is over, ending *the curse of the Bambino*. Next day there was a lilt in the air all over the city. At school my friend Josh Frank remarks that there are two choices. You feel either like holding on to your pain as a die-hard Sox fan or you feel like tipping over cars.

A sculpture park with one of my pieces is being dedicated on the South Shore, and Mary and I drive down to the ceremony. Dr. Steven Andrus was one of the great benefactors to art in Boston and my best patron. He commissioned an eight-foot sculpture in red cedar and steel that sits along a blue stone pathway. The curator, Paul Master-Karnik, former director of the deCordova Museum, wrote in the catalog,

Suggesting a road less-traveled that does not lead to anything but itself, Dewart's construction reveals a space to contemplate both the view before us and the view behind us.

November 2004

As the sun is setting on a golden fall day, I notice another fulcrum moment as Peter Haines and I set up an exhibition of bronze sculptures in a Harvard gallery, where undergraduates—young men and women—hurry past full of conversation, intensity, and ambition, as I once did, and children are playing in the leaves under a maple tree all ablaze in the last of the angling light, with tomorrow the presidential election day, everything in flux, as winter impends, and I am caught in another sunstruck moment, time out of time.

November 2004

Kerry appears to have lost, as the tally is slowly made, and I talk with Jep about where the pain of this loss is going to go. I talk about the narrative meditation I have made for my coming show, perhaps using a scrolled LED panel. Slowly a new space opens up in my inner life, and I notice how much distraction I have had in my antiwar frame of mind. I mention a feeling of openness to Ross Gelbspan, who chides me. "How can you talk openness when the prison bars have just descended?"

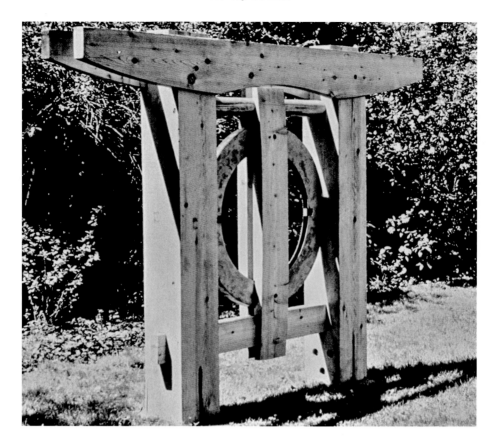

November 2004

I have a long, epic day with my assistant Ifrane installing the half-ton sculpture *Kyrie* in a law office in Times Square. There were dicey moments as we ramped off the granite blocks and suddenly a bomb scare caused all the doors to be slammed shut and locked. I regretted not using a truck with a hydraulic tailgate, as the granite banged down off the ramp in its unforgiving way. The law firm was high end with beautiful paintings, a Jim Dine and Frank Stella prints. The architect handling the placement seemed pleased. In Times Square, Ifrane and I take in the Jenny Holzer *Truisms* scrolling in LED lights. They are the perfect embodiment of sculpture as a combination of poetry and engineering.

NO RECORD OF JOY CAN BE LIKE THE JUICE THAT JUMPS
THROUGH YOUR SKULL WHEN YOU ARE PERFECT IN SEX

On the drive home, Ifrane asked, "What's next? What are we going to make next?" This is a delightful prompt, and I begin to plan a big piece to mark Brookline's 300th anniversary. Mary has a hot meal waiting on the stove and gives me a Buddhist reminder: clear the underbrush from my soul and burn it away.

Another big competition looms for a Boston site, and I am one of three finalists, proposing an open gate form twenty feet high made with stainless-steel angle and many lights. The competition is flawed, the money evaporates, and the whole process goes awry. I am left with the drawings and a lovely maquette that sits on a studio shelf until one day a sculptor friend gifts me with a leftover truck load of aluminum angle. I realize I can use these for a gate fifteen feet high that just scrapes the ceiling of my studio. Aluminum is relatively inexpensive and easy to truck and, in taking paint, opens me to a whole new world of color. Why not red, the good-luck color? I build a big red gate and install it among the trees at the Chesterwood Museum. Just as I am fastening the bolts on the concrete base, David Lang, a sculptor friend, shouts across the field, "It is fucking beautiful, beautiful!" How wonderful to get such immediate feedback, and it is a rarity. I install the piece in four different exhibitions and finally sell it to a Chicago collector.

Murray Dewart

November 2004

Winter has arrived, and several inches of wet snow cover the ground. I tightly wrap the two sculptures going to the casino in upstate New York in my open truck, and they just graze the door jambs as I pull out of the studio. It's a long drive through farm country in the growing dark. In the distance, implausibly, a twenty-story casino tower looms, brightly lit, a God of Mammon, luring the farm boys and the hapless small-town gamblers. I visit the main casino, where someone has had a medical emergency and is lying facedown with their glasses broken. The EMTs are wheeling in a stretcher, but on all sides the gamblers at slot machines, inexcusably, don't look up, intently working their compulsion. Next day I wheel my sculptures to their sites in the hotel lobby, where a baby grand piano plays *Joy of Man's Desire* electronically, with no one, I mean no one, at the keyboard. There should be a law against this kind of thing.

December 2004

Our house renovation is almost complete, but the decisions are very taxing and difficult. One of the most prominent triggers for divorce is renovations. Mary and I have a flared-up misunderstanding in the tile store. It is the tone of my comments that infuriated her, which seemed entitled, patronizing, and dismissive. Mary's view is that the painful family dynamics surface in order to be healed. We cannot paper them over with nostrums and bromides, which was often the style of my family growing up.

January 2005

We settle into our renovated house with a peaceful calm. Walking on a clear night around Jamaica Pond together, we count the stars and planets, call our sons, and check in with them. Listening to Bach, we build fires in the fireplace and bring friends for meals in the big new kitchen with the long slab counter. I plan with my Harvard classmates our coming reunion and a symposium "on reinvention." We have been warned that after the twenty-fifth the reunions turn melancholic. I share at a meeting an old refrain that I cannot place: *"Riding into the sun of myself on a horse that knows the way I drink deeply and begin my song."*

Hammer and Tongs

March 2005

I am working on a plan for a nineteen-foot-high sculpture, a temporary piece for my thirty-fifth Harvard reunion. My brother, Chris, teaches at MIT, and I work with him planning how to engineer it. In the yard adjacent to my Everett studio is a huge pair of wooden beautifully fluted columns that I can borrow. For a base, I reuse the steel from an earlier sculpture and weld it up. On my calendar, I face a daunting set of tasks in the coming months: big sculptures, a gallery show, a reunion to help organize, classes to teach. How will I stay attentive to Mary and to my sons? One night, Mary and I turn on some music and use the newly renovated hallway to dance a Virginia reel. The next day we enjoy a Sabbath loaf and walk the seashore at World's End south of Boston, gathering stones, glad that the long winter is over.

April 2005

Loading the truck one day using a wheelbarrow and a ramp, I push my luck too far and get rolled backwards off the truck, spraining my ankle badly. The emergency room is close by, and the staff remember my last studio accident, when I came with a sliced hand needing stitches. This is a cautionary experience as I head into a big installation with an inexperienced crew.

Mary and I go to hear Robert Bly read poetry accompanied by a sitar player, and I am struck by his wisdom path, and his wonderful translations of Basso and Rumi: *"One moment's inattention with your beloved and you ruin the whole thing."* From an old Spanish poet, he pulls out the concept that our great privilege as artists is that we get to turn all our experience, even our failures, into nectar, clear sweet nectar.

April 2005

I head to the airport for a visit with Caleb as the magnolia blossoms in the front yard lie scattered, as Jep said, "like party favors after the prom." I have left behind on the studio floor a dozen new bronzes that I need to sell. The image of distillation occurs to me, that the work of art is to distill with the heat and fire of the imagination something of lasting value to leave behind. I am thinking about my *Sabbath Loaf* sculpture sparked by a challah loaf, sexual in a subliminal way, with its polished stones reading as eggs and new life, even while they are granite millions of years old. How long will it be around as a sculpture? At least, I think, to my granddaughter's wedding day, should Lucy Clare decide to marry. In Caleb's garden, Lucy lies on a blanket in the shade under an orange tree. The air is thick with the blossom fragrance. Caleb and I begin a conversation that drifts toward an argument. I say, "I did not fly across the country to argue with you."

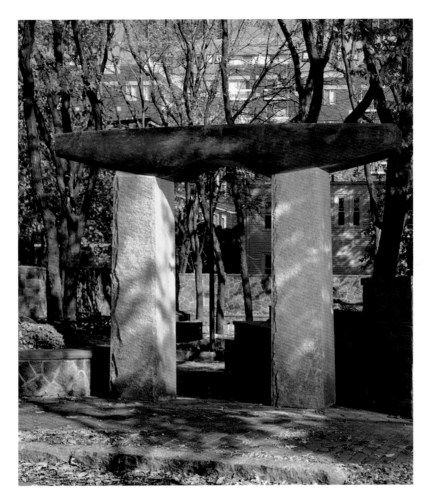

April 2005

I hit a wall of exhaustion after my red-eye flight home, and the studio work requires great caution. I put one foot in front of another, coil the extension cords and slings, sweep the floor, and try to avoid an accident. The big *Moon Gate* sculpture is half completed, and I wonder what color it will be. Red is the good-luck color, but white is best for being visible in the dark if it goes to the Boston Common in December for First Night.

In the gallery Joe Wheelwright, Dan Wills, and I have a conversation about the dangers of early success. Joe had a sold-out show not long after graduating from Yale, but it was an event that overpromised. Joe, like me, has made his mark like a steady draft horse, decade after decade, following a plow toward a far horizon. Dan's friend Frank

Conroy had an early bestseller, *StopTime*, then wrote nothing again anywhere near as good, drank hard, and died a few weeks ago. His later years were very sad. Joe remarks, "Maybe, Dan, you'll prove to be the more lasting artist." Dan has new work that is wonderfully inventive, full of antic wit. He is a legendary teacher at the Museum School but could use more recognition as a sculptor. He has a running joke about his work going into a municipal collection, namely the town dump.

May 2005

Mary has pushed her garden's redesign in magnificent new ways. It follows what we experienced in Soujou, China, where rooms opened wide to the garden. We've a new bluestone terrace with stone steps, new trees and shrubs and flowerbeds, her years of experience as a landscape designer finding expression. Mary is deeply alert to everything. Sometimes, remembering George Eliot, I say that *she feels the grass growing and hears the beating of the squirrel's heart.* We were having a relaxing dinner, and Mary was starting a story about her newest client when the sight of a bird above the trees caught my eye and I ruined the moment, as Rumi warned, with a second's inattention to my beloved. I have reawakened the hurt she experienced with her inattentive mother. When will I ever learn?

May 2005

I am calling my exhibition at Boston Sculptors Gallery *Late Flower Alphabet*, borrowing an image from Elaine Scarry's seminal book, *The Body in Pain*. She has a phrase at the close: "The moral generosity of a people is sometimes called the late flower of civilization." I have a set of 26 bronze sculptures that suggest a new vocabulary or alphabet, a residue of symbols, Hebrew letters, Chinese characters, Native American iconography that all point toward something new, some future where everything merges. Justice Holmes wrote that the law is the record of the moral order of human culture. Elaine Scarry expands on this, recounting how the Bill of Rights evolved, how Christianity emerged out of Judaism, how Protestantism emerged out of Catholicism, and each transition is marked by extending individual rights to an ever-widening group. I call her and we talk through the text I am including in my exhibition.

The occupation in Iraq begins to look long-term, and Secretary of Defense Rumsfeld concedes that a ten-year American presence is a possibility. The newspaper now puts the daily bombing casualties on the back pages. Was there a tipping point? Just one too many front-page photographs of dazed survivors, bleeding and holding on to their shoes? I go walking along the Muddy River on the one-year anniversary of the Abu

Graib photos being made public, thinking about American liberty and about moral generosity, and the scene of prisoners held naked, beaten and tortured. Just then a windfall of blossoms blew down across my path, delicate petals, thousands upon thousands, as if ... as if Neruda or Isaiah or Elaine Scarry sang out to me, "Coraggio! You there, brother! Have courage! Pass it on!"

May 2005

A call comes that my cousin Julia Randall has died. She lives now in her words as few can do so beautifully. She wrote:
Should I be gone
(tomorrow, perhaps, I will not answer the phone)
think of me not as graceless, but as grown
whole in my tongue. And should you pass
between hours through your wall of grass,
iron, and oak, here where my quiet work
runs like small waters under the pared light
that swallows love,
here we could speak.

I try to read a poem of Julia's to a class, but I have to stop because I am afraid my voice will break.

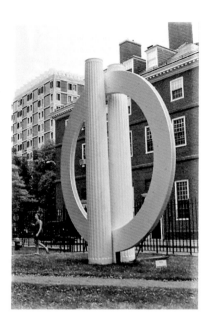

June 2005

With a work crew of three assistants, I install *Moon Gate* outside Quincy House at Harvard and get modest approbation from passing crowds. I feel all the tension drain out of my body in one sudden moment, as the installation went without a hitch. I drive to the airport to pick up Nate, and at home he plays his newest song on the piano with the refrain "open wide the gates." Solana is finishing her graduate program in urban planning at MIT, and we have a dinner with her parents, a warm and generous couple who have raised an amazing daughter.

I wonder if being an artist is premised on some kind of solitary, questing need. Is it born out of loneliness? Talking with my friend Dan Ardrey, we compare the stories of our youth, hitchhiking across Europe as I did in 1968 and across Africa as Dan did. The wonderful sculptor Louise Bourgeois said, "I am a lonely long-distance runner. If I were fully healed, I wouldn't have to make sculpture. If it's not therapy, it's not art." Louise had to escape an impossible, domineering father, and there is something extreme in her position. In my own case, my father was always obliging to me, not in the least bit controlling, though he could be exasperating. My mother was wonderfully supportive, my two sisters were very close to me in age, and I had a sweet brother much younger. What was it that I needed? Why did I travel so far from home? At eleven, I had the chance to work for a month on a Maryland farm and I loved it. Tractors, old farm trucks, riding hay wagons with West Virginia mountain men who chewed tobacco and swore with vivid, colorful language when

they skinned their knuckles on machinery. I didn't get homesick, and a pattern developed where my summer jobs sparked my independence. Was it my father's inattentiveness, absorbed as he was in his work as a pastor to three hundred souls? I worked on boats, in the rough world of big hotels and restaurants, and in the rougher world of Wyoming oil fields. We would cross the state line into South Dakota for 3.2 beer and try not to get into fistfights. There was the drilling engineer who confided about our favorite waitress: "She glories in fucking." It was the legendary *rite of passage*, part of a young man's ritual training. Spending time in *the school of hard knocks* seemed part of it. My father had his hardships, I had mine, and then I passed it on to my sons. Girls are more protected, just as my sisters were. When Caleb and Nate turned sixteen, I gave each of them the keys to the family car, my credit card, and instructions to go to the Vineyard, find a summer job, a place to stay, and don't come back until you do. For both, it was a difficult but powerful passage into young manhood.

Being an artist involves an extended conversation with yourself, and these began for me in my long summer forays into the far country. Yeats said, "Argument with others yields rhetoric, argument with yourself yields poetry and art." At twenty, along the roadways in France, Italy, Greece, and England, I walked alone with a bedroll, a journal, and a copy of *Ulysses*, sleeping in fields, under boats, and under bridges. From this experience, I grew undaunted. The dangerous world of art and artists did not intimidate me. The year 1970 was a time of tremendous upheaval and rebellion on college campuses. Why did I go to my Harvard graduation wearing coveralls? I was graduating with honors and heading to Vermont to make sculpture and build a cabin in the woods. My father and grandfather could not hide their disappointment. When you go against the precedents of three generations, you own the decision in a very big way. That ownership is useful. Art can be a long *lover's quarrel with the world*, as Robert Frost said. Is it only our willful, stubborn resilience as artists that keeps us from getting heartbroken?

July 2005

I am thinking of how Robert Lowell shaped my understanding of art. However impossible he was as a person, he was an important presence in Cambridge and Boston, a tall man, with a slight stoop and an absentminded air. His poetry was given to us as assignments in class. There were puzzling lines, and Philip Fisher would say, "Just go ask Lowell what he meant." My friends Dan and Marty were mentored by him, and Mary traveled with him in the presidential campaign of Eugene McCarthy in 1968. He marched in the street demonstrations with us and took the stance of prophesy. I take a page from his playbook as I plan my fall show, with the Iraq War grinding on. Lowell was always engaged with the fate of the republic and wanted his art to reflect this. Peter Haines warns me that *politics is the death of art*, but I brush this off.

I have twelve-hour work days welding in the Everett studio. There is a big bronze-and-granite sculpture that is causing me agony as I try to resolve its form. I made castings off an old bell, but I can't get the piece to be coherent. I keep grinding it, rewelding it, obsessing it, hoping to include it in my show, but its form grows more and more muddled. I think of the George Bernard Shaw quote "I want to be thoroughly used up when I die for the harder I work for that enterprise larger than myself the more I live."

An errand to the hardware store takes me up Main Street in Everett, and I remember waiting for my friends outside the Church of the Immaculate Conception. I was an outlier in being the only Protestant in my Catholic neighborhood. We played *ringalevio*, running and chasing games in the streets and the concrete backyards long into the twilight. One afternoon I went alone to the Main Street Cinema to see *White Christmas*. I had the novel experience of watching Rosemary Clooney and being completely enthralled by her. Something powerful awakened in me, and I was entranced. *I wanted to find her and marry her*. I walked out of the theater onto darkened Main Street, and suddenly it dawned on me: I was just a seven-year-old kid in Everett, Massachusetts, and she was a long way away, likely with Bing Crosby, and our romance wasn't going to work. I felt sad and disheartened. It was first about a love-crush not working out. Later I saw it as my inclination to dream large, impossibly large, and sometimes this has been useful.

Murray Dewart

August 2005

The newspaper each day triggers heartburn, as the blundering Bush presidency appears clueless about the error of the Iraq invasion. George W. Bush has a "famous father" problem, needing to act out an Oedipal drama at the White House, showing visitors the big Colt .45 pistol that was captured from Saddam Hussein.

I prepare the press releases for my fall show, *Late Flower Alphabet,* and plan a poetry reading in the gallery with Elaine Scarry and Alice Quinn, the poetry editor of the *New Yorker.* I email the *Globe* and the *Times* an op-ed piece I call "War Journal," but it doesn't run. It is my first show in the new South End location for Boston Sculptors Gallery, and I sell three big bronzes at the opening. Mary throws a dinner party afterwards, and forty people come back to the house. At the welding supply store, the big-hearted Milton reads the review in the paper and says, "Cut me a piece of that Sabbath Loaf."

We have a reading with a big crowd at the gallery. Alice Quinn is close to the pulse of antiwar sentiment and reads powerful poems that have run in the *New Yorker.* Elaine Scarry reads from Patrick Henry's speeches about the Bill of Rights. The *Alphabet* idea fascinates her, and she holds up cards lettered with the Greek alphabet and reads a Seamus Heaney poem. The Jack Gilbert poem called *Brief for the Defense* is read by Alice, but a noisy bus went by and drowned out the words. I leap up and read it again, because something important is triggered:

In the ruthless furnace of the world, we must risk delight. We cannot let injustice be the only measure. If the locomotive of the Lord runs me down, say that my end had magnitude.

The last day of the show, my best collectors arrive along with Christine Temin, art editor for the *Boston Globe.* I've sold big outdoor pieces and have lots of footings to complete before winter. I visit my mother in her retirement home, and she greets me with "Hail, champion! Everybody's talking about your show."

At the new convention center in South Boston I install my fifteen-foot-high *Memory's Gate,* as a temporary piece. The money is short, so we use an installation crew of custodians from the convention center. The scaffolding is set up and half a dozen men begin scrambling around, shouting in Spanish and Portuguese that I can't understand. I realize somebody is going to get killed, and I decide to leave off the topmost steel element. It looks novel without it. I am exhausted and happy, sitting on the curb enjoying it when some architects stroll by to take it in. I overhear them say, "It seems Shinto crossed with Methodist," which delights me.

I have been thinking about Rilke as one of the artists who have influenced me the most. He urged young artists to find humble employment and ordinary work because "we must not burden our art with the ulterior motive … to impress it with hopes and wishes." I have found part-time teaching to be reasonable employment. Almost every sculptor I know does some kind of teaching. It's indoor work with no heavy lifting. The students at St. Anselm College call me Professor Dewart. The students in the Brookline schools listen to my stories, and Rilke's advice has been useful.

September 2005

At Bennington College, I organize the memorial service for Julia Randall. In her last instructions, she had specified playing Bach and "no Jesus, please." She was very fond of St. Paul, however, and referenced him often in her poetry, because he was a good writer with a great Latinate style. I open the service with the lines *"Earth receive an honored guest, Julia Randall is laid to rest." Poetry Magazine* puts on its back cover Julia's won-

derful poem *Tallis Canon*. The family talks about using the last line for her tombstone: *Lord, that I am a moment of your turning.*

With Alice Quinn, I cast about for an unpublished poem of Julie's that the *New Yorker* might run, but have no luck. I notice how a distillation has occurred, how Julie's impossible, cantankerous personality has vanished into memory. Her poetry has now spun free of her, and the purity of the lines, like hammered gold, endures and rings true. She has disappeared into her art like a songbird into a blossoming garden.

November 2005

A new project in China emerges as a possibility, and I go looking back in my archive for a particular sculpture. There are thirty-five years of sculptures scattered all over the world and sitting out in the weather. On the one hand, the thought fills me with pride in accomplishment, that I have endured and persisted as an artist. The other feeling is one of exhaustion and fatigue, remembering the labor, the concrete footings, the sense of responsibility for the welding and the patinas in Beijing, the chipped granite in Fuzhou, the stones in Lima, the steel piece near Tel Aviv. If I were thoroughly conscientious about all this, I would likely go nuts.

I get a call from one of my clients. There is a songbird perched on the sculpture I made for his garden. Would I come sometime for lunch? We eat on his terrace, and I take in how little the sculpture has changed in ten years out in the weather. It seems to suggest half a dozen things: a lion roaring, a soldier at attention, a cathedral door, a cruciform, lovers linked at their genitals, a household under one roof. Artists give the world metaphors, and if you can imply three or four in one sculpture, you're lucky.

In my father's latter days when he was ailing, he had a prominent picture of me welding at a jobsite with a twenty-foot steel sculpture, *The Pegasus Arch*, rising behind me. He left his sickbed to come and hear me give an inspirational talk at the Harvard chapel. Leaning on his cane by the door at the close, he smiled a kind smile and said, "Now I can die. Thank you, Mac."

I remember one bright summer morning when I was preparing for my fall exhibition. We were staying in Vermont, and I headed over the mountain in my truck to the lumberyard in Bristol to buy some 5/4 ash planks to rip into walking sticks. It seemed to evolve into a day of rare sightings filled with grace: an angelic child bouncing on her grandmother's lap in the hardware store, a great blue heron in the mist by the riverbank feeding, a red-headed girl earnestly sweeping the path by the Jerusalem Four Corners General Store. I asked her where Jerusalem was. She smiled, pulling back her

long braid, and said, "There's nothing really there." At the edge of town in Bristol was a giant boulder etched with the Lord's Prayer, where I had to admonish a gang of ragged, thoughtless boys who were busy with sticks, teasing a three-legged dog. I followed a streambed as it rolled away past the lumberyard and gathered smooth granite stones for a sculpture in progress. Along the steep road home, beautiful and forbidding, I found prayer flags and a sign, implausibly, for a Tibetan nunnery. Cautiously, I knocked on the door and engaged the woman abbot in conversation. She had a shaved head, wore an orange robe, and had a face of keen intelligence and curiosity. She eyed me warily: a tall man in dusty work clothes smiling an open pilgrim's smile, a journeyman, living out a parable filled with poignancy. Back in my studio, later on, my newest sculpture seemed to gesture, reassure, and console me, as if in words: "*Square the heart to the brightening day.*"

November 2005

We have a big dinner of sculptors and painters sharing war stories of long years with galleries and dealers and impossible commissions and reviewers. Collegiality among artists is deeply valuable. Our ailments and accidents become part of the shared story, as Dan Wills and I have grown partly deaf from forty years of noisy power tools. Illness can produce a focusing concentration, as happened with Keats, D.H. Lawrence, and Matisse, by clearing away distractions. Bedridden with arthritis, unable to hold a paintbrush, Matisse used a long stick tied to his arm for marking his late cutouts. Courage and fortitude are the keys to a long career in art, just as they are keys everywhere.

Murray Dewart

December 2005

I make an illustrated picture book with rhymes for my granddaughter Lucy at Christmas called *Ponies on Parade*. In 1977, I was working in a boat factory on the N.H. coast. I didn't have time enough to make sculptures, so I made woodcuts, and these are the illustrations. Part of the book explains the Dewart clan story, my Scottish ancestors, the MacLeans on the Isle of Mull. After the battle of Culloden, they couldn't get work as MacLeans, so a group of cousins changed their name to Duart, then Dewart, which was the name of the castle.

> *Lucy Locket: she can fuss like a*
> *MacFusserton of that famous fussy tribe*
> *whose hats may smell of cheeses*
> *while they're always talking Jesus.*
> *They love dogs and talk for hours*
> *Play loud music, carry flowers.*

December 2005

I teach my last class for the semester at St. Anselm. As students file in, I like to play loud rock music, like Credence Clearwater Revival. As one of my requirements, students need to know three knots, three prayers, three ways to cook a fish. Call this my Zen koan. We have been practicing the knots. I have a grill, and today we draw lots to see who will cook the salmon I have brought. We eat the meal on my best family china, and I give each student a rose and wish them fulfillment in love and work. Later, emails pour in, saying they were touched and moved by what I said: "Some of you may radically change the world for the better and for the good, and it is that hope that motivates me as a teacher."

January 2006

My friend of forty years, Dr. Richard Kornbluth, comes to town for a medical conference, and we have long talks and walks. We visit the Buddhist temple at the Museum of Fine Arts and talk about the redemptive power of art. Richard is a brilliant thinker, and we parse out how beauty is a sacramental offering. In museums we encounter lost worlds; tomb doors from China, Egypt, and Rome; the burghers of Rembrandt; the lovers of Rodin; the girls of Degas and Gauguin; the gardens of Monet, all preserved and intact and somehow redeemed. Richard has high praise for my newest bronze, called *Pilgrim*, which signals something original, something from the uncharted part of the

map. In his laboratory, he works on the frontiers of cancer research, and his imaginative labor matches my own, peering into a microscope to unravel the mysteries, maybe of what Stevens called *dominion of the blood and sepulcher*. My cousin Julia would always say that the magical element of art was *bringing into the world something new and never seen before*. In her poem *Airborn*, Julia writes:

I take my tongue in my hand, awake to acorn and blood, let burst in the fall oak, blind as a worm whose ground way rockets the bones of the sky til they sing home on the wing of the word at the wind's end.

In 1996 I mounted a show called *Jerusalem: On the Wing of the Word* at Boston Sculptors and invited Julie to read along with Geoffrey Hill, hailed by Donald Hall as "the greatest poet writing in English." They were a curious set of readers, Julie owlish and somewhat frail, Geoffrey Hill, austere and trembling, as he read Isaiah on Jerusalem. I had built a set of sculptures that were gatelike and took their titles from the Jerusalem Gates. *Damascus Gate* I placed on the north, *Zion Gate* on the south, replicating the layout of the old city. The Psalms, after all, are the hymnbook for the lost first temple, and we reconfigure it in some way when we recite the words. The poets understood this imaginative leap and delivered the words with great mastery.

January 2006

Caleb calls and announces that Lisa is pregnant and carrying, he says, "a little man." *O, the wonder of new life approaching out of the dark, out of the duende.* Mary and I talk about the idea of transparency, that we try to hold in our hearts both the past and the future. Can we live a truth that honors our ancestors and also provides inspiration to our children and grandchildren?

Passing by a classroom one day at school, I hear the voices of children singing "We Shall Overcome." It seems a teachable moment, and I go in and tell them about Freedom Riders, about my mother going to Washington to lobby senators in 1963, about my father going to North Carolina to work on voting rights the year the Ku Klux Klan was at its height. I ask them, "Are any of you ready to raise your hands and be Freedom Riders?" I watch many hands go up, and I feel a powerful emotion sweep through me.

Peter Haines and his wife, Sekio, have just returned from a trip to India. Sekio muses about happiness. She witnessed in Bombay scenes of abject poverty and wretchedness but saw on the faces only a strangely blank acceptance. I give her a copy of Jack Gilbert's newest book, *Refusing Heaven,* because he parses ever so clearly the entangled question of beauty and suffering.

We must risk delight. In the ruthless furnace of the world, we cannot let injustice be the only measure.

I visit Jep at the cathedral where we are forming a committee to plan rebuilding and renovating. There is an empty space in the pediment of the Greek Revival church that has bothered me for thirty years. Why empty? There were limestone blocks set in place in 1820 for carving, but the sculptors never came. All the talent for carving was likely in Italy. We begin to hatch a plan for a competition to find a sculptor. Jep has a charisma as dean of the cathedral and a clear-eyed intensity. He's not sure how the process would

work. I keep saying, "Trust the artistic imagination." He was on a path of spiritual discernment, he said, hoping to trust God in the process, all the while attempting to sort out his needs, fears, hopes, and insecurities and trust that somehow God would work with them or through them.

I talk with my neighbor Ross Gelbspan about our respective accolades. He regrets that his father was not alive when he won his Pulitzer. Ross asks me, "What does it feel like when you complete these big gorgeous bronzes?" I tell him there's a mixed sensation of all the construction details still being obsessed, wondering about the durability of the patina or a cracked weld that might cause a problem. This is overlaid with a big-picture satisfaction. What a privilege to have done this unusual thing! To have endured for thirty-five years making sculpture in the face of the world's resistance. I share the

joke about the made-up Sanskrit word for *artists hurling themselves at the world*. Ross, like me, understands that our marriages and our children likely matter more than any worldly accolades.

In my drawing cabinet I rummage through stacks of old drawings and find some red-and-blue ink drawings from the 1980s. When I showed them in the 1990s, Christine Temin in the *Globe* wrote that they had "the bright force of late Matisse." The forms prefigure in some way my newest sculptures, both monumental and sacramental. I always hear the comment that my work seems Asian. This is a mystery that I cannot really explain. In the early 1980s I had designed a pulpit, and these drawings evolved from there. The cover on Robert Pinsky's *Figured Wheel* book seems reminiscent of my sculptures. It is a reliquary or tabernacle form of some kind from a mystical Jewish sect. Robert explained to me it came from a museum in Chicago, and the rule of the group was the design must not use any iconography from the past. How is it that I have wandered back into this?

On the phone with Nate, we talk through our climate change project, mailing to every member of Congress Ross Gelbspan's book *The Boiling Point*. He is getting interested in public policy and thinking about graduate school. All the members of his rock band are getting the same inclination at the same time. The hardscrabble life of being musicians, driving in a van to Cincinnati, playing a gig, then sleeping on the floor, is starting to wear thin. Solana has her graduate degree from MIT and a new job at Policy Link, and her wisdom and focus are helpful guides. It's a recurring story in my family: women offering *saving grace* to men, protecting them from themselves. Mary has been my guardian angel in this as well.

James Taylor made the remark that to survive as an artist you need to keep your overhead down, avoid a major drug or alcohol problem, and stay out of Italian sports cars. I have an issue with my overhead, in keeping my two studios operational. I am tired of the long drive to Everett and the grimness of the town. Thieves stole the copper off the overhead crane in an adjacent space and pulled up the railroad track behind the building to sell for scrap. I decide to move the last of my materials out and sell my TIG welder to my friend Jim Montgomery. From now on, I will hire his foundry for my welding. My smaller studio alongside the garden, quiet with lush flowers and hummingbirds, is beautiful and will have to suffice.

January 2006

I finish the patina on a bronze for Alice Quinn and ship it out. I first met Alice on a Martha's Vineyard dock when Caleb and her nephew were fishing for tadpoles. She has been my friend and supporter for many years, before I had an audience for my work. She has

supported many, rediscovered old or overlooked poets, championed the new, and been an evangelist for American poetry. At a New York dinner, the gathering of poets raised their glasses: "May we all keep having an Alice Quinn in our future." Alice shares with me what a *Vanity Fair* writer said: "Mac has his sculpture, he has his religiousness, and he has Mary."

January 2006

Walking to Coolidge Corner in the snow, I meet a homeless woman who has gotten her cart stuck in the rails of the trolley track. I work at getting the wheels unstuck when she suddenly turns on me, punching me, saying, "Get away from me, you animal." I step away, and a passerby, a young woman, says softly under her breath, "Bless you, bless you." What is it that I am doing, pulling children and the homeless out of the paths of cars and oncoming plows and trains? Is this a Dewart being a Dewart, one snowy day?

February 2006

A blizzard has struck Boston with more than a foot of snow. My mother calls, saying she was reminded of the winter day in 1948 when I was baptized in St. Johnsbury, Vermont. It was thirty below, and I was marked on my forehead with the sign of the cross, where

maybe it froze and stayed put all these years. My mother is finishing her memoir and wants to put an image of some sculpture of mine on the cover. She is a storyteller, born in Richmond, proud and sometimes class bound. She was the first woman in her family to go to college, and at Smith, Betty Friedan was a classmate. My mother's feminist side is entrenched. My father, on the other hand, was a populist in the way clergy need to be. During the Depression he had worked three years in the steel mills after losing his college scholarship. Their marriage was a boisterous love affair, and mealtimes were noisy and argumentative like a Jewish or Italian household. When Mary first came to dinner she was startled, wondering how this family could ever digest their food amid all the loud arguing and talking.

February 2006

I keep the poetry and the letters of Rilke close by my bedside. He had a spiritual understanding that had broken free of organized religion. He worked for a time as Rodin's secretary and saw up close the relentless work that sculpture required. There was a steady stream of clients coming to the celebrated Rodin, eager to have their portraits done. Rilke saw that the clients assumed Rodin's fame would somehow transfer to them. *Fame*, wrote Rilke, *is a collection of misunderstandings.*

Clearing my big studio and lifting some big steel plates has triggered a hernia problem, and I go in for some repair surgery. I banter with each of the nurses. One has an artistic son. One announces she's a terrible cook, and I give her my three-minute cooking lesson: (1) know your tools, (2) build your meal from the sauce up, and (3) pay attention to how the food looks. The anesthesiologist with shining white teeth asks, "Do you want the twilight or the Full Mickey?" "Bring on Mickey," I say. The nurses ask about my website, and I tell them to Google my name. "You're famous," one says as I feel the anesthesia's white cloud envelop me, conscious of fame's wide misunderstandings.

February 2006

Oliver Wendell Holmes said we must live through the passion and the heartache of our times or some might say we have never lived at all. In my convalescence I read widely, focusing on the prophetic imagination and how artists take inside themselves the central ideas of the historical moment. Henry Moore with surrealism, Picasso with Marxism however briefly, Rilke and Matisse with the tragedy of World War I. The war paralyzed Rilke, but Matisse burrowed ever more furiously into his work. He knew his sensuous paintings burned with the life force, and he knew broken Europe needed this to heal. Gauguin reflected the fin de siècle boredom and malaise and set out for the

South Seas to reinvent himself, the same way Delacroix had gone to North Africa in 1845. I find a passage from Anni Albers:

Art is always a personal, moral adventure. We learn courage from art work. We have to go where no one was before us. We are alone, and we are responsible for our actions. Our solitariness takes on a religious character: this is a matter of my conscience and me.

February 2006

A huge Shiite mosque is blown up in Baghdad with two hundred killed, and Hamas claims big victory in Palestine. The Iranian zealots have gained power, and the whole disastrous sweep of consequences from George Bush's blunder comes into view. The Democrats need fifteen more congressional seats and then John Conyers, who is pressing for impeachment, becomes head of the Judiciary Committee. I need to keep all this in view at the same time as I take in the peace of a silvery dawn breaking forth in the God-given eastern sky. Later in the morning I buy for Mary a small wooden bird. The pretty salesgirl asks, "Is that the one speaking to you?"
"Why yes," I say. "The universal language. It's the bird that sang I am."

A postcard comes from Jep, who went traveling to Galilee, and there's a beautiful view of the water. He writes, "I didn't walk on it but I swam in it. Prayed every morning on the roof of my hotel in Jerusalem."

The curator from the Danforth Museum calls with questions about the bronze of mine that is now in its collection. I talk about the great privilege of being an artist in conversation with the artists who have gone before. Museums are the places where the conversation across the centuries takes place. Picasso once was given the run of the Louvre to place his paintings next to old masters, which he promptly did. "I held my own with Zurbaran," he said. "I gave Tiepolo a run for his money, but that bastard Delacroix could paint."

In the Louvre once, I found a medieval church reredos where onto the back the sculptor had carved into the oak, "Je suis Joseph. Priez pour moi." What would be my prayer for poor Joseph, the anonymous carver? Since the Enlightenment, the voice and vision of the individual artist, separate from institutions like the church or the royal court, has taken primary importance. Our singularity as artists is what gives our calling its draw and its romance. "What I do is me, for this I came," wrote the poet Hopkins. In the ancient past, sculptors would labor in anonymity in the service of emperors, pharaohs, or the city-state. An exquisite basalt carving of a proud face stares out at us from the Middle Kingdom of Egypt, the sculptor unknown but the human feelings captured by

the work of the sculptor's hands. The sculptor Donald Judd made the comment that the most-important works of art grow out of belief systems. In so-called primitive art, there is almost always a fierce sense of the life force coming through, "the spiritedness" of forms. Henry Moore describes how in successful work, there is "an alert tension that exists between the parts, a pent-up energy and vitality independent of any object it may represent."

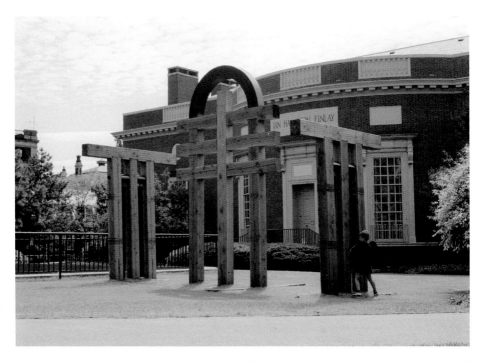

Sometimes the need to solve the problems of a sculpture are agonizing. I can go round and round, obsessing when something feels wrong. Is the proportion off, the color of the granite wrong, the patina distracting? At other times the silence of the studio is consoling with the new work unfolding. The sculptures are not bellowing or yammering in their neediness. The new waxes hold promise, the granite reassures me. The biggest new gate near the window is awash in sunlight, and its woven forms seem spliced with yearning, celebration, and lament, as if all my experience had crystallized into durable bronze and granite. Sometimes Mary notices a calm in my demeanor and an absence of churning when the work is going well.

I imagine my granddaughter wearing the silver brooch I have designed, modeled on the fourteen-foot-high sculpture I built in Alabama. I imagine her telling a story someday. "My father's father once upon a time made this and gave it to me on my birthday." Could it be that the smallest bronzes will have the likeliest chance to survive, say my

bronze portraits of Mary? As sculptors we have our immortal longings, building works that may or may not outlast the everyday, maybe enduring somewhere out the wide Elysian plain.

Thomas Merton in 1968 encountered in Ceylon the big sleeping Buddha cut into the hillside. He wrote, "There is no mystery. All problems are resolved, and everything is clear, simply because what matters is clear. The rock, all matter, all life is charged with dharmakaya … everything is emptiness, everything is compassion."

Two of my colleagues at the gallery give notice they will be leaving, somehow having lost their belief in the public process of exhibiting work. We mount shows and exhaust ourselves, sleepless, broke, running on fumes in the final stretch and then waiting on the world's approbation. It may or may not trickle in, a comment here or there, a scrap

of paper with a friendly note, or a petulant review. Chuck Close spoke derisively about art critics. To Deborah Solomon of the *New York Times* he said, "You are like the meter maid. All you do is bring people grief."

I have always loved Gauguin, his romance and renunciation of the modern world. At a Gauguin show at the Metropolitan Museum, standing in the darkened room with throngs of people crowding in, I suddenly found myself choked with emotion. He had suffered so much to leave this work behind. Reading the sad chronology of his life and looking at the beautifully luminous colors of the landscapes and the girls, I thought of all the artists I have worked with and known, their struggles, their poverty, their madness and epic battles to be understood. Gauguin had an emblematic solitariness and a ruined family. He was syphilitic and suicidal and never knew for sure what he had accomplished. At the end of it all, a handful of shimmering sculptures and paintings. Wrote T.S . Eliot, "These fragments shored against my ruin."

March 2006

I visit a show of Frank Stella's paintings at the Sackler Museum. He's an artist who has influenced me with his bold, restless reinvention, sometimes with an Apollonian and geometric bias, sometimes Dionysian and wild. He had a series of large protractor paintings, vividly colored, that took their titles from pilgrimage sites. I always loved his *Damascus Gate* painting, and it sparked my entire series of *Jerusalem Gates*. I met him at a party in New York, and we talked about his teachers. Patrick Morgan at Andover was one, and then at Princeton a teacher whose most negative comment was "That's interesting." I shared Kokoschka's remark that if you last as an artist, you'll live to see your reputation die three times. I asked him where he was in this. "So many times I've lost count," he said.

My Guggenheim letter of notification is sitting on the mantelpiece in the living room awaiting opening. I delay this several days, both imagining the big party I would throw to celebrate, and imagining where I would place the pain of the disappointment. The commission for the Boston Police taught me that I need to avoid being wounded by these random decisions by distant committees. With a busy day before me, and a new commission to plan, I open the letter, glance at the opening sentence with its apology, then throw it into the trash.

Hammer and Tongs

March 2006

I fly to St. Louis for a weekend and a long talk with Nate about his career plan and about the 500-book climate project. Nate has picked up the mantle of activism, very strong in Mary, who can be the highly organized person to implement change. Nate is growing in his leadership skills and has a wide range of gifts, especially emotional intelligence that complements his analytic probity. I have called him a wizard ever since he was seven and began beating me in chess.

And great news from Caleb: Wilder Bingham Dewart was born that afternoon, and we fly to California to share the moment. Wilder has taken the old family name, and, being a Dewart as well as a Bingham, he will likely reinvent it.

I meet William Reimann for lunch, and we take a walk over to my Cambridge park. He was the teacher at Harvard who awakened me to what sculpture might offer. At Milton Academy I had delighted in the painting studio but did not take it seriously as a career. It was too sketchy and dangerous, dominated by colorfully self-destructive characters. It seemed a ramshackle direction. Yet, I loved making things, working with my hands, my two mute companions, and here was the affable Will Reimann, burly and Yale educated, a family man with a charming wife, who was a painter, and two lovely children. Will had chosen sculpture as a career and had made for himself an interesting life. On my park design Will had good comments, liking the mystery, the three-dimensionality, and the surprise elements. He is experienced with granite and notices my careful joints where the bronze meets the stone. His commentary has always been analytic and discursive, never effusive. I had fought with him in 1970 about the direction my work was taking in the classroom, and we gave each other the silent treatment for about a week. Maybe fighting with your teachers is important. In the park are young mothers with bundled-up newborns on this, a first warm day. Will and I peer down into the bundles, delighting in the newness of life coming to the walled garden that I have made. Somewhere the word for "paradise" translates as "walled garden." Walking through my nine-ton gate, Will and I are smiling and I cuff him on the shoulder, glad for such a day.

Word comes down that Harvard University has agreed to purchase *Sun Gate* for the McKinlock Courtyard at Leverett House. I share this with everyone I meet, call all my friends, banter with neighbors in the street. Our successes, I often say, are born of earlier failures, but only when we persevere. There is a dinner at Leverett House in my honor, and Will Reimann comes and I give him a shout-out.

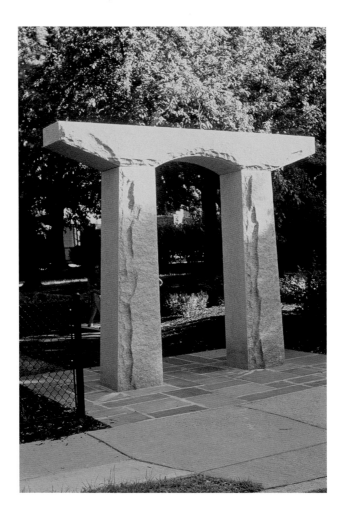

My nine-ton gate for Brookline moves forward as I order the granite and obsess over the final proportions. It seems to resemble the Greek letter "pi" along with recalling the Egyptian gates with its mass. I toy with adding words but then decide I want simplicity. I take a quick trip to New York to see the David Smith show at the Guggenheim, and I am fired up. He pushed and pushed sculpture into an entirely new direction. He fought with the curators but was generous and community-minded with his friends, especially the women sculptors Beverly Pepper and Anne Truitt, who wrote, "If David was alive, I knew he was working." I am most inspired by the late Cubi series, masterworks of an Apollonian grandeur.

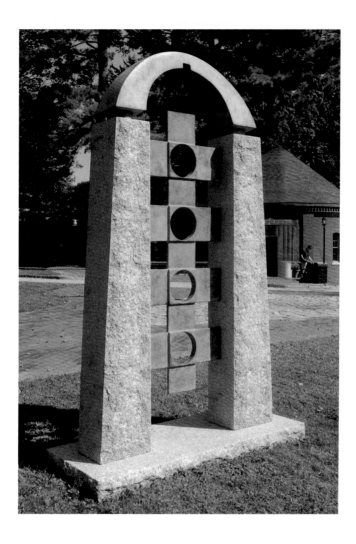

Alice Quinn hosts another dinner after a reading of Elizabeth Bishop poems with a group of poets, including Robert Pinsky. We pass around the question of what adjective do you choose for your work. I take issue at first with this and share the thought from Huxley that language is a means of taking the mystery out of reality. This gets pushback, of course, from a table of poets. I share that "noble form" has been applied to my sculpture but that I am puzzled by what it means. Pinsky said *graciousness and courteousness* are implied. I said I wanted the adjective "prophetic" applied to my work, and I felt the group pause, maybe with the recognition of this.

The political landscape darkens when the Bush White House reveals there's a plan in place for a nuclear first strike against Iran. In the *New Yorker*, Frank Bidart's poem "To the Republic" is worthy of Robert Lowell:

I dreamt I saw the dead from Gettysburg risen disconsolate
that we ruin the great work of time … you betray us.

Why is it that the Republican Party repeatedly splits the country apart along the old fissure point?

A fierce denunciation of Bush occurs when the great Yale chaplain, William Sloan Coffin, dies and his old sermons are rebroadcast. He was a clergyman most like my father, with a physical style, with a thirst for justice, speaking truth to power when the moment was right. With my three siblings one night, we listen to Coffin's voice on the radio and hear echoes of my father, and we smile with delight. The four of us hold a summit meeting to discuss my mother's health. She is too frail to join us when we all go to the Easter service at Trinity Church in Copley Square. We talk about her coming to the next big wedding, of my nephew. I remind her that her heart has an arrhythmia problem and she could die in her sleep. "That would be wonderful," she says with a laugh.

Mike Schiffer calls me on Passover, and we have a long talk. I share with him a dream I had that we were traveling together with our wives somewhere in Afghanistan where the roads were paved with Oriental rugs. We talk about our current projects, and I share the thought that our destinies are already realized, come what may of the work still to be done. It's what Mallarmé said of Valéry and what Bidart said of Lowell. It's the sense of our achievement not conditional upon winning something more, some Guggenheim or some exterior standard of fame. We both face the pressures of the marketplace where a younger and younger generation is always shifting the paradigm even as we press forward reinventing ourselves. Someday we'll call it quits and I'll put my tools down at the edge of the sea. Wrote R. L. Stevenson:

Under the wide and starry sky
Dig the grave and let me lie
Glad did I live and gladly die
And I laid me down with a will.

The garden off our kitchen is exploding with blossoms, there are jays and cardinals in the trees, and it's another halcyon day of spring. Caleb calls from Los Angeles and says, "I'm sitting here at home with this little guy in my lap." There's nothing better than new life pressing forward, from the god who breathes the day awake, when the bud and the Buddha are one.

One day in the teachers' room at school I tell the story of Dakota and Laura, who had come to my studio the day before. Their father was my Vermont friend Tom, with whom I shared a maple-sugaring operation in the early 1970s. He was a fierce worker, gifted, multitalented, but somehow marked for tragedy. He played the violin, and when his house burned, he ran in to retrieve it. One tragedy after another kept happening. In the end I was left with his charred violin after he killed himself. I kept the violin on the wall of my studio for thirty years because I knew someday his two young children would grow up and seek me out. They called one night out of the blue and came by, because the father they had never known lived in me as a presence, the way grief keeps alive our lost friends. We talked for hours, wept, and shared stories, and they took the charred violin home with them. The teachers in the teachers' room nodded with the poignancy of the story. I apologized for my intensity, as I sometimes need to do. They said, "Oh no, Mac, your stories inspire us; you're like listening to NPR."

Something about Wilder's birth and Lucy's birth has induced a new poignancy to my everyday. I am starting to see the seven generations that constitute the shorthand of "forever." I remember the nicknames and the stories about my eight great-grandparents, and should I be lucky enough to see Lucy's and Wilder's children, that's seven generations. In my early sculptures in the 1970s, I carved wooden relief panels and there were always figures carrying figures, a woman or a man carrying a child, a man carrying a woman. It was the simplest way in physical terms to convey spiritual interconnectedness. In the words of an old hymn, "We are not divided, all one body we."

Matisse has a magnificent painting at the Met in New York. It is of his son playing the piano, and there's also a small sculpture of his in the foreground and an unfinished painting in the background. There's a metronome on the piano to help the son play. And what richness of color! Matisse worked at being a good father as well as a good painter. In the Hilary Spurling biography, you can see how Matisse struggled early in his career against the critics when he was called a crazy fauvist, and later in his career when he was deemed "too bourgeois" in painting nudes in the South of France. His best works were hidden from view in Russia after the revolution and locked away in Dr. Barnes's collection in Philadelphia. As is often the case, it is miraculous that these works have endured. I often mention the heroism that a career in art often requires. The world tries to talk us out of it, to set in place myriad impediments. Artists are those who feel the mysterious pressure to take something out of silence and give it form, whether for the eye, the ear, or the hand. And just as the Buddha said, we are always at the beginning.

I get a call from a former student who remembered a glove story I had told at a graduation, and wondered what it meant. Artists give the world metaphors, I tell him. That first glove I found, one fall day biking up the turnpike to the school, was brand new, a lineman's glove with a high gauntlet, a right-hand glove marked with initials. I used the

glove all winter as I welded up sculptures. In the spring of the year, on the same stretch of turnpike, I looked down one day and saw the left-hand glove of the same pair, newly fallen in the road. I was on the trail of someone making the same mistake twice, and I knew his initials. How unlikely was such a finding? How implausible the reuniting of a pair? Is it the long endurance of staying a pair, like marriages, decade after decade?

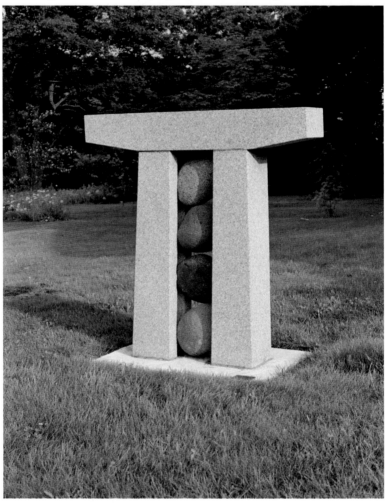

In *Phaedrus* Plato writes, "The inner world and the outer world of the wise person are in balance." As artists, our privilege is to make our inner world visible and knowable to others. The wisdom we achieve has its cost. Sometimes the faces of artists reflect wisdom of the serene kind, but it's rare. In David Smith's face, captured in photographs, there's often an agonized look. In Monet's face, late in his career, you can see how worn out his eyes are, with the evidence of deep strain, from watching, squinting, staring into the light. In the portraits of stone sculptors like my late friend Joe Wheelwright, there's

often one hand placed on the back, always a sore back, strained by the work of carving stone. When artists make self-portraits, they are often severe, marked by a soulful scrutiny. Matisse, late in life, dressed in a suit in the South of France, peers out at himself, quizzical and questioning, in no sense reflecting that he was the greatest painter in all of Europe. I have a self-portrait now in bronze, done in 1971 as I began in sculpture. The brow is furrowed, the mouth is severe, the eyes are very intense. "Lighten up, Mac," Mary will say, "and soften."

In some late careers, faces register a jubilance, a low twinkling fire, a self-knowledge and a self-realization. Two poet laureates come to mind, John Masefield and Robert Pinsky: *the inner world did not consume the outer world.*

By the sea on Cape Cod there's a half-ton granite-and-bronze sculpture of mine that needs to be moved. Bought by a wonderful collector, the late Stephan Stone, it needs to be reinstalled at the home of his daughter. I remember the moment of the sale. It was the last hour of my exhibition at Boston Sculptors, and I was beginning to close up. An unassuming man in a baseball cap was leaning by the wall in the corner, contemplating my five big sculptures on display. I did not know that Stephan was one of New England's preeminent collectors. He had a modesty about him that was touching. My brother has joined me for the work, which he often does on projects, as we disassemble the granite and ramp it, piece by piece, into the truck. Chris is on the faculty at MIT and is gifted in every aspect of material science. How it is that the two sons of a clergyman became builders? Jesus was a carpenter, I sometimes say. Our father liked to build things, and we built a boat in the rectory basement that's still around. In 1980, Chris and I built a pulpit for the church where our father had been rector, after a devastating fire. I did all the carving, but Chris did all the basic structure. When we finished the pulpit, the art editor for the *Globe*, Christine Temin, came by the studio with a photographer. "The *Globe* loves to cover church fires," she said. The picture from that moment, two brothers carrying a pulpit into their father's church, was prized by my father and kept by his bedside. Love, said Wittgenstein, is always put to the test, especially in the father/son relationship. Chris and I grew into our destinies, as all children must do, in our parents' wake. Our wise and stoic mother balanced and moderated our impulsive, sometimes exasperating father. "Calm down!" she would say to him, just as she says to me.

July 2006

I fly to St. Louis to hear Nate's last concert with his band, as they play a big prestigious venue, a club on the river called Mississippi Nights. Nate is a powerful tenor, and his voice soars out over the throng, and I am conscious of how much energy his singing requires. As always, Nate is the tallest person in the big room, and he later works the crowd like a politician, as I do, talking with group after group. Next day we lounge in the park under the St. Louis Arch, and Nate is spent and exhausted from the concert. He shares how extreme it is, physically, to perform and then to crash. It is a difficult art form that he is leaving behind, and graduate school looms like a quieter prospect. He has mastered all the details of our 500-book project, and he's halfway done. It is a com-

fort to us to have marshaled this project into being, as an antidote to the unrelenting bad news of the current government.

The granite coastline of Maine has been a natural destination for my sculptures over the years. I had an embarrassing installation once where things went wrong in full public view. It happened with an early granite piece in the center of an island community in Maine. I had a scaffolding set up, and a crowd had gathered around me as I set the final top stone in place. The alignment needed an ever-so-slight adjustment, and I was using steel bar clamps. New to using granite, I was unfamiliar with its tensile strength and the issue of grain in stone. Trying to adjust the last quarter of an inch, I broke the main column and the entire sculpture collapsed with a roar into a broken pile. The crowd was stunned, and I felt humiliated and out thousands of dollars. For months I would wake in the night remembering the sound of the breaking stone. Years later, back in Boston, a smug neighbor told the story with a smirk, and I felt like belting him. There was a trauma lodged in my bones that wouldn't go away. The sculpture now looks beautiful with the new column I substituted, and the broken stone was used for another commission. Wrote Yeats, "All things fall down, and we build them up again."

Mary and I return one weekend to the Maine coast. In a rock outcrop along an estuary, I have a revelatory experience. It was a water-formed fissure, a cleft like a miniature Grand Canyon. There were seedlings that had sprouted, delicate life forms that had taken hold, with spiders in attendance that crossed the cleft with their webs, working hard to find sustenance, joined by sluggish beetles meandering over the stone slabs. I saw that life was a momentary coincidence of water, seed, and light. Mary called out to me, "What have you found?" I called back to her, "*The truth about the world!*" For Plato the metaphor was the cave, for Emerson the tunnel, for Emily Dickinson and John Donne the spider and its web. Isn't that what we prize most in art? When we see into the heart of all things? Say that *French Suite* of Johann Sebastian Bach, when it conjures up a couple, a loving couple, dancing a gracious dance? Or Henry Moore's massive reclining figures, as if weathered down to the bone but still smiling somehow, like Etruscan tomb figures.

I deliver sculptures for a faculty show at St. Anselm and have a long talk with the charismatic dean, Father Peter Guerin, who is fired up about teaching Plato. He uses the word "anthropic," a term for describing the earth's fortuitous coincidence of factors that allowed life to flourish. With a great buoyant smile, he says, "God had chosen this rare moment for life in the universe." I share with him my experience in the rocky outcrop on the Maine coast. He gestures to the sky beyond the abbey bell tower, and I get a sense of the light shining through him. St. Augustine said, "Be yourself and let the fire of God burn through you."

Murray Dewart

July 2006

I am at work on my next exhibition, trying to wrestle into place a new set of sculptures. Am I deluding myself when I think of them as prayers, the way Seamus Heaney calls his poems prayers? The big ring form that shows up in my work seems an emblem of wholeness, at-one-ness, outside time, of that ritual moment where time stands still. I am planning a sculpture called "Double Happiness" and am trying to arrive at the right scale. The stone columns need to fit into the elevator at the South End gallery, and that is my constraint. For David Smith, the constraint was the door of his Chevy van. For over-the-road transport, eight feet of width is a constraint. We dream our vast, magnificent dreams, and the world provides it constraining context.

Emerson loved Shakespeare's *Tempest* most of all because he prized the imagination over the intellect, over reason. "The great day of days," he wrote, "is when with the inward eye we see into the underlying unity of all things." Do I want my sculptures to signal this? My last exhibition had its wartime meditation, but I think I am done with that. From Jack Gilbert, I have followed the injunction to "risk delight" and to pull the nectar out of the world as a moral imperative. From Matisse I have learned the same lesson, as he painted in the South of France during both world wars, as wartime pulled in all three of his children, as his daughter joined the French Resistance and was captured by the Gestapo. His moral imperative was to paint beautiful, sensuously colored paintings that would be restorative to the broken world, that would heal the life force wounded by war. So I work at making my sculptures somehow harmonic. With Peter Haines, a difference of opinion emerges. I say I work at making my sculptures true, and if they are true, they will likely be beautiful. Peter, however, says he works at making sculptures that are beautiful, come what may of their truth.

August 2006

With Nate and Solana, we rent a house on Chappaquiddick, where in my childhood we would spend the month of August. There is a majesty to the silence there, always a sea breeze and the smell of honeysuckle. With my father and grandmother, we would have outings with our watercolors. Positioning ourselves by a tidal pond or estuary, it seemed as if there was a mystery we were trying to unravel, some secret we waited on. In my adolescence, the landscape took on a sexual aura, the soft, feminine dunes plied open by a brook. Chappaquiddick has remote beaches lost to time where we could run naked into the surf. Pastoral and coastal landscapes hold a subliminal appeal, deep and archetypal. They prepared me for understanding Wordsworth, then Emerson, and I posed to myself the idea of being a landscape painter. The island towns were filled with galleries for the tourist trade. One year in Oak Bluffs there was a novel gallery filled with

small kinetic sculptures made of wire. I went home to Boston and tried my hand with wire, solder, and miscellaneous car parts.

Solana knows the name of every bird. An osprey nest sits below our rented cottage, and the great birds wheel above the bay hour after hour. I watch a pair of monarch butter-flies, moving from flower to flower, all morning, thinking somehow a divinity is pres-ent. I remember Emily Dickinson: "In the name of Bee and the Butterfly and the Breeze, Amen." At sunset I discover that the birds have eaten one butterfly and left the gorgeous wings. Maybe a kind of communion, I think, as if the bird swallowed the sacramental part but left the beauty. A full moon rises, huge and ravishing above the marshland. All is change, all is motion, as the restless sea scours the sandy shore.

August 2006

I go to the stone yard in Barre where the granite for the Lawton Gate is being cut with a wire saw. The workmen are proud of how beautiful it looks, nine tons that are exquisite in their proportions and heft. I visit my friend Steven Korshak in Barre. He was married in a hay barn in 1970 to Katha, who was eight months pregnant, and it seemed a scene out of Homer or Beowulf. Swallows flew in and out of the barn above our heads as Steven read that iconic passage from the *Duino Elegies* of Rilke:

> *Because all this here and now seems*
> *to require us, us the most fleeting of all*
> *Once and never again. But having been once …*

Steven is an endlessly inventive character, raised in Chicago by a stern orthodox patriarch. Steven is head of the Vermont Ginseng Association, and he gathers and buys this rare root from others. Wild ginseng is prized over cultivated ginseng, and its mystical properties, promoting sexual vigor, have been prized for thousands of years. Knowing how and when to find the wild plants is a deeply kept secret. It is sold by the ounce at extraordinary prices. In the Vermont dialect it is called "*dingshang*," but few know how to find it. The *dingshang* hunter needs to stay secretive and walk miles and miles in the high canopied parts of the forest during late summer, when the plant can be found. The Chinese prize most highly the roots that resemble the human form. Sometimes ginseng is translated "likeness of a man." It is the very first impulse in the history of sculpture to find the human form or human face. It is an impulse that never goes away. The massive clothespin sculpture by Oldenburg in Philadelphia, Corten steel 25 feet high, still reads to us as a pair of lovers in a sexual embrace.

Mary introduces the idea of how sculptures are yet another way of preserving the patriarchy within human culture. How many lifetimes, we ask, will it take for the patriarchal bias to diminish? At Boston Sculptors Gallery, we have tried to keep a balance of men and women. On college campuses there's the constant challenge of gender balance because the women are better at being students. My father was a patriarch of the old school, and he wrote a note for his grandsons:

> *A man needs to know his destiny*
> *for what and for whom. A boy*
> *needs to know his history for coming*
> *and going.*

With Jep, I begin a conversation about sculptures for the front of the cathedral, in the blank pediment space at the top of the facade. We have a joking discussion about the

iconography of the different religions. Christianity has Christ being nailed to a cross. Judaism and Islam have no figures at all. Buddhism has Gautama sleeping in a prone position. Hinduism has Krishna being royally laid. In Washington, DC, the National Cathedral has some pediment figures of Adam and Eve by Frederick Hart, something of a riddle, with their soft-porn quality. I think of Krishna and his bosomy consort in that lovely refrain in Pinsky's Worcester *Art Museum* poem: "Julio and Marie will fuck forever." Jep and I share the view that Boston has too much figurative sculpture and it's time to mark the new millennium with a breakout sculpture.

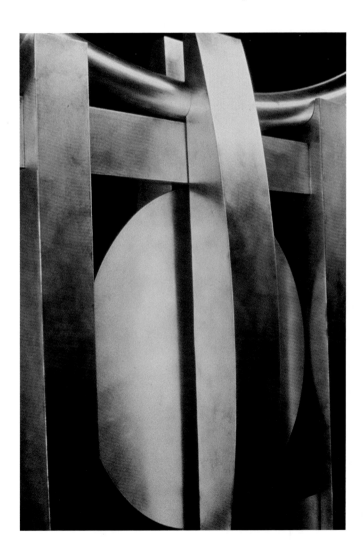

Murray Dewart

September 2006

The midterm elections loom in November, and I brainstorm with my Brookline friends and with my neighbor, Mike Dukakis, about talking points for congressional Democrats. Jep and I join Bill McKibben in Vermont for a ten-mile protest march against global warming. We meet Bernie Sanders in the crowd, and I tell him about our 500-book project. I notice how Jep and I delight in our callings, partly because we had to break the family mold. He was born into three generations of military, and I was born into three generations of clergy. We are both imaginative, and when you go against such a precedent there's no turning back.

At Boston Sculptors I have set in motion a symposium of public art called "Art in Context, Context in Art." There's a great crowd, a great panel, and a good dialogue. I had a brief sensation of embarrassment when the most highly celebrated of the artists were laughing uproariously about the old days at MIT and I suddenly felt left out. It was momentary, the feeling left over from grammar school, and it's a novelty for me, a flash in my otherwise generally calm self-assurance. David Smith refused to meet Picasso when he had the chance, as he didn't want to feel overshadowed and his insecurity got the better of him.

I am remembering my years as a young artist when other people, prompted by their own insecurity, would say savage things like "You are no artist with those carvings you are making" or "I know real artists in New York and you are no artist." An art critic in the *Boston Globe* wrote a similar review, early on, that I quickly tore up and threw away. How is it we endure these blows, body blows, slams to the head and to the heart?

In my colleagues Peter Haines and Joe Wheelwright I see my own stubbornness reflected, my driven self, my relentless capacity to endure and not to take no for an answer. I pitched one of my sculptures for inclusion in a prominent museum. The director wrote back, saying, in so many words, "Who the hell do you think you are?" I let some years pass, a new director was hired, and I tried again. "Well, of course, that's a wonderful sculpture that we'd love to have." I now see that many of my successes are born of earlier failures, but only because I persevere.

November 2006

The Democrats take control of both House and Senate, and Deval Patrick wins as Massachusetts governor. He scatters his mother's ashes on Election Day, remembering her words "You don't have to be afraid because you can always come home." Deval Patrick and I had the same mentor teacher, A.O. Smith at Milton Academy, who taught us how

to write and speak in images and how to cook. I feel jubilant about this sea change in Congress and call fifteen friends to talk it over and celebrate.

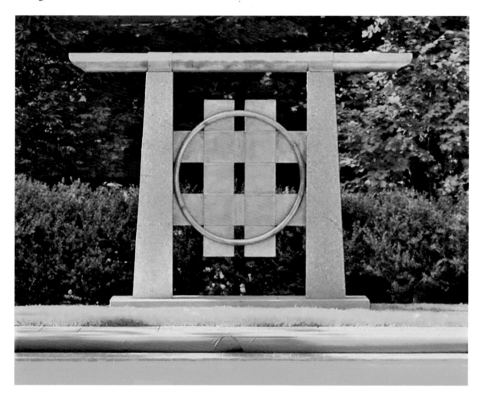

I spend a day with a twenty-ton crane installing the granite gate at Lawton Park. Donny Jaynes, the rigger, is deeply experienced and I have come to rely on him, to relax when I hear the roar of his crane coming up the street. There is a slight misalignment of the stones, and he uses the truck to push them sideways, ever so slightly, until the steel pins drop into place. I smile with relief, jubilant that the gate's elegant simplicity has finally coalesced. The jobsite where half a dozen men are working has a curious feature. Every morning at the same time, a naked girl comes to the window of the adjacent apartment building. She is bosomy and stands combing her hair, aware that all the men are watching, and aware of the distracting power she has over them.

With the installation over, I tape a television interview and drive my mother over to the park for a look. Then I take her to hear the poet Mary Oliver read to an overflow crowd in a big auditorium. My only job, Mary Oliver says, is to love the world. Her poems are prayers, and, once again, I wonder how my sculptures can be prayers.

There's a memorial service at Harvard for Dimitri Hadzi, a sculptor and longtime professor who has influenced me, though not as a teacher. He used granite in a masterful way, took chances, and pushed his medium in an inventive, sometimes risky direction. Leo Steinberg called Dimitri "the best unknown sculptor in America" and "a sculptor's sculptor." He was something of a European classicist, though Brooklyn-born. After the war he went to school on the G.I. Bill and spent many years working in Rome, where the American Academy became his base. Dimitri and Seamus Heaney were great, close friends, and they were traveling in Greece when word came that Seamus had won the Nobel Prize. After the service, I banter with Robert Pinsky about American art and our predilection for the hustler and wiseacre, which Hadzi was distinctly NOT. America favors the wry impresario, say Jim Dine, Warhol, Jeff Koons, Christo, Claus Oldenburg, or Yoko Ono.

December 2006

I have an exhibition in ten months, and a set of big sculptures are getting worked toward completion. I like the title *Double Happiness*, as it will mark my sixtieth birthday and Nate and Solana's wedding plan. We drive to Cleveland to give them our ten-year-old car and stop at the Turning Stone Casino, where my sculptures are sited. They give us a room at half price, and it's the most elegant place we've ever stayed. At breakfast, they serve us Eggs Benedict with caviar under a suite of my bronzes that look elegantly polished, and it absolutely delights me.

I go for a walk before dawn along the Muddy River and visit my favorite oak tree silhouetted against the lightening sky, remembering the lines from Isaiah about the great oaks read by a rabbi at my father's funeral. Oak trees have a resilient strength and so did my father. He walked by the Muddy River every morning, wanting to stay in touch with the nonhuman forms of life, which, as D.H. Lawrence observed, "rebuke us in our vanity." There was a turtle he encountered every year at the same time laying her eggs, and then a duck, sitting on her nest, inside the very wall of Temple Israel, under a flowering cherry tree. *All things merge*, he would say, *and a river runs through it.*

At the Fogg Museum, I have a talk with Harry Cooper, a curator, who had given a eulogy at Hadzi's memorial service. We parse the careers of major sculptors: When is it they hit their stride, and when is it they lose their way? I share the story of visiting Beverly Pepper's studio at Todi near Rome, remembering Hadzi's competitive feelings toward Beverly. They were both from Brooklyn, both worked in Rome, but Beverly managed her New York reputation more skillfully. She could be acerbic, but she spoke warmly of Dimitri as we sat in the Italian summer heat drinking lemonade. At Boston Sculptors, we are always competing against each other for sales and for big commissions, but the

intention of maintaining the bond of community tempers the competition. Dimitri was sensitive about being overlooked. Of one art critic, Dimitri said, "That guy could use a seeing-eye dog."

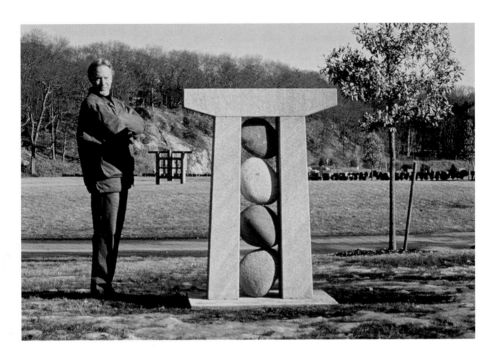

Christmas Eve 2006

On Christmas Eve, a call comes from my old friend Joan. "What was that prayer you taught me years ago?" "*Benedictus benedicat.* May the blessed one bless us," I say.

February 2007

I have finally solved the center section of my newest gate. I laid it out flat on the floor and stared into the mystery of it, deeply moved, and I can't say why. It had a power like something long buried and brought into the light. Partly, it was the bronze talking, sand-cast and pockmarked, welded, and peened with its gnarled strength. Partly, it was something else, some yearning, some need, some hunger to get to the heart of the world. Is that what's called a spiritual dimension? In the poems of Jack Gilbert there's the refrain "What comes next?" I go visit Jep to talk through this. He's laid up with a badly broken arm. I remember a sermon he gave. He was in the hospital with a woman

whose child had just died in her arms. She turned to the nurse and asked, "What do we do now? What comes next?"

I walk the winter hills of the Arboretum, dusted with a light snow, and hunt out my friend, an old red-tailed hawk that frequents the tall hemlock trees. It's the "comforting immensity" of the natural world that Neruda mentioned that I'm needing, as the Mideast blows up with car bomb after car bomb, the cost of the Iraq invasion is in the trillions of dollars, and I fear for the fate of the republic. I read a Mary Oliver poem to Mary as I cook supper in the fading light.

In my studio, I jury-rig a lathe, using an old refrigerator motor. I want the center element of my *Golden Gate* to have grooves in the ring. It's noisy, dangerous, and a little wobbly, but it works. There's a novel, handmade look like something from the distant past. It feels like a sculpture at home anywhere in ten thousand years of human history.

Returning home one night, we find a message on the answering machine. Our friend Peabo Gardner, calling from the intensive-care unit at the hospital, would like me to make a large seven-foot birch tree cross for his funeral. It is the custom of the Russian side of his family. The next day I drive to a New Hampshire woodlot with an axe and a chain saw. Calling Peabo back, I learn he has died during the night. I save the answering machine recording: his voice is strong and clearly focused on all the details, the phone number for reaching his wife and his children. Love, as always, is being put to the test. Jack Gilbert has the line "Love allows us to walk in the sweet music of our particular heart."

One of my favorite recordings at the moment is a Joni Mitchell song where she speaks as "a lonely artist living in a box of paint." It seems to be a recurring theme of mine, the solitariness of the American artist. David Smith spoke of his *crushing loneliness* at Bolton's Landing after his second marriage failed. Camus, T.S. Eliot, and D.H. Lawrence all remarked that the great American talents have all been solitary and isolate. I broach this with Pinsky at a dinner, and we test the concept with Thoreau, Emerson, Dickinson, and Faulkner. Pinsky asks, "Would it have been better for Emily to have written abolitionist poems like her contemporaries rather than her private solitary meditations?" Michael Heizer has been working alone in the Nevada desert for nearly fifty years in a situation comparable to Smith's. Do I overstate this as a theme? Is it particular to American artists? It's rare for American artists to be honored; more often we are ignored. Russian artists, for example, are more frequently persecuted, jailed, and censored, like Pushkin, Tolstoy, Pasternak, Solzhenitsyn, and Joseph Brodsky.

I talk with Jep about loneliness and his childhood moving from military base to military base. My father moved from church to church, and each time I had to say goodbye

to my friends and start over in a new school and town. Both Jep and I became avid readers, a consequence of this. I also loved the solitary work of building things late into the night at my big workbench, cutting, shaping, and sanding small boats, airplanes, and model cars. Picasso described how he loved to work at night under a single light, as if he had left his body at the door, the way Muslims leave their shoes on the way to their prayers. I was about twelve when I began to love the blank sheet of paper and the chance to dream up whatever came to me. I understood that my imagination was the strongest part of my constitution.

At the cathedral Jep introduces me to Mary Oliver, who was there for a reading. We talk about the Psalms, how they marked an important point in our spiritual evolution. In them there is an intimate, personal conversation with the Creator, and it is the same stance we see in Mary Oliver's poems. "Maybe the desire to make something beautiful is the part of God inside of us." Mary Oliver has a sweet delicacy about her, teases Jep with humor and radiates kindness.

March 2007

The winter has been long, the studio work exhausting, and I am feeling worn out and spent. I decide to head to Vermont to escape the wartime news and to walk the hills alone. I drive to the deepest stretch of woods I know, then hike for miles. The sun is bright in the crystalline silence, and I lie down to rest, stretched out on a fallen tree. I doze, lazily watching the wispy clouds, when suddenly, out of nowhere, there's the thunderous roar of a supersonic jet screaming low directly overhead with a rush of air, then another, and another and another. It's the weekend reservists from the Chicopee Air Base, and I don't know whether to laugh or cry, it's so absurd a coincidence. Try as I might to forget George Bush and his war, he hasn't forgotten me, here on this remote wilderness mountainside.

April 2007

Terry Strom asks me to go to Jerusalem in September. "How can you not go?" he asks. We have lunch at his lab, and he introduces me to his large staff. Terry always seems like my long-lost older brother. He's a world-class research doctor, athletic and Chicago street smart, the kind of intense and profane big personality I enjoy. We were having a big dinner with twenty people when the phone rang. Terry grabbed it and then shouted the message. "It's Nate and he's proposed to Solana and she says yes!"

Late one afternoon I head toward the granite quarry in Vermont as the light is fading on the warming spring fields. I keep wanting something nearly impossible, a sculp-

tural form that somehow gestures to the hills and sky, that illuminates the inexpressible "thusness," the light on the hill, the clouds rolling in from the east. Along the interstate highway, the best view in the valley is given as a war memorial to Vermont veterans, Vietnam veterans, as if there were arms wide open enough to hold that emptiness and loss, all those young soldiers who never made it back home. I park my truck by the memorial and lean my head against the door in tears.

April 2007

We fly to Los Angeles for Wilder's birthday, and I sing him to sleep in my arms. We spend hours in the park playing, as Lucy has her father's endless energy and Wilder laughs and laughs just watching his sister. These grandchildren seem like the nectar of new life. They have blossomed with the love that Caleb and Lisa have given them. We drive to the beach north of Malibu and make drawings in the sand, dogs and cats, horses and flowers.

Alice Quinn comes to town to give a talk and stays with us. She recites a Seamus Heaney poem as she's on her way to Dublin to meet him on an editing issue. We talk about the alertness required in art: we need to stay ready for the coincidence of light and form and sound and color and meaning. There is almost always an inner poetic revelation pressing forward into the world if you stay alert to catch it. Alice shares with me this

question: Are we to be post-Christian in a modernist world or postmodern in a Christian world? She and I have been most shaped by the poets Eliot, Bishop, and Rilke, the *Four Quartets* and the Duino Elegies, as we parse these questions.

I am at work on a proposal for a thirty-foot-high Las Vegas sculpture, using a team of designers. My ink drawings are transformed into CAD images, brightly colored turquoise and magenta; they have a gaudy popinjay quality, like showgirls crossed with saxophones. The team effort makes it fun, but we don't make the cut, alas. I love the drawings, and maybe they'll make their way into another project, as often happens.

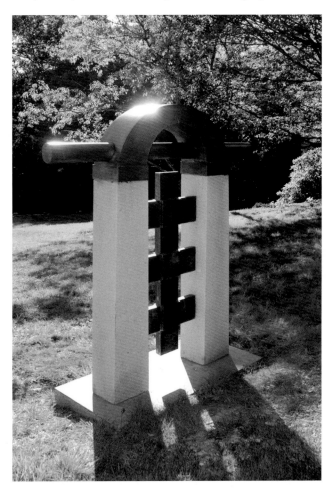

I call Ernie Wilson in Los Angeles and learn he's been appointed dean of the Annenberg School at USC. He is always a great affirming presence, and we talk through the speech he is writing for his inaugural moment. Occasionally he's been getting congratulatory

comments along the lines of "a brother from the hood, making it to being dean." He's feeling the need to correct this, feeling being dean is his family business, as his father was a dean at Howard and his grandfather a distinguished historian. This reminds me that so often there are others who want to tell our story, to make a narrative that is not our own. With identity politics, so called, we can wander into the wrong or inaccurate narrative that someone else is writing for us.

Mary and I collaborate on a garden design, and I install a big bronze at the end of a long terrace and flowerbed. I start to understand what Henry Moore said about a sculpture's vitality, how it needs to have vitality and an alert tension between the parts. The scale and proportion of the parts need to be ever so carefully calibrated or the "alert tension" is flawed, the columns are too thick, or the top element too wide, or the entire sculpture too small for the site. Even the august Metropolitan Museum of Art can get things wrong. The Noguchi sculpture on Fifth Avenue is slightly too small for the site. An overly large base was used to correct this, but it dissipates the "alert tension."

At the foundry we are welding together the big bronze center section of my piece called *Double Happiness*. It refuses to get plumb until two of us, with sledge hammers, pound it straight. There's some banter going on about the sexual innuendo of the phrase "double happiness." I share with the men the rabbinical commentary about orgasm, that by allowing a woman to take her pleasure first, the likelihood of sons is increased. The entrenched history of the patriarchy is a long one.

I attend the funeral for a client and neighbor, and something about the burial service irritates me and seems "over the top." I have trouble with the vision of reuniting with all the saints. I am a believer and at home with the peace that passes understanding, but I share the view of Tolstoy that personal immortality seems like some large misunderstanding. I find the communion ritual a powerful comfort two thousand years old. *God is a rumor kept alive in human history.* I think about that longevity as the cup is passed, Charlemagne walking barefoot in the snow on Christmas Day in the year 1400 to greet the pope, Henry the Fifth ordering communion after the battle of Agincourt and the slaughtering of prisoners, the poet Rimbaud on his deathbed, my grandfather in 1918 giving communion to twelve hundred men before the Battle of the Marne. Writes Robert Stone:

If you can't believe it, maybe you have to hope you will. If you cannot hope, then love the idea of it. Love it like a secret lover. It's the only meaning in all of things.

July 2007

We have a big family gathering with children and grandchildren at a rented house on the Cape. Lucy is talking a mile a minute. I walk down the beach with Wilder on my shoulders, and he delights in being seven feet tall, pointing out birds and cooing his speech. There's eight of us dining on lobster at our big round table when I say the Emily Dickinson prayer. Caleb is writing an HBO pilot with a touching father-and-son narrative. Nate and Solana are making plans for their St. Louis wedding. At sunset we all walk down into the tidal flat, and I am touched by the bounty of life as the sun drops down into the sea.

At the studio one day I am preparing to ship a sculpture, and one section of granite is too long. I always try to be careful about noise, but the shippers are scheduled to arrive so I cut the granite outside the studio door. It is taking awhile, and then I see a policeman walking up my driveway. O Lordy. There is no worse feeling, because I know the noise has offended a neighbor. I apologize profusely but feel sick about my quandary, bollixed, jammed with a deadline, frustrated by my lack of options, and trying not to show anger to anyone, especially a policeman. I bring a bottle of wine to my neighbor. I am remembering Dimitri Hadzi had it worse. His neighbor was a policeman who worked the night shift and needed daytime quiet, almost impossible for a granite-cutting sculptor.

Listening on the radio one evening, I heard a voice in an interview that sounded somehow familiar, discursive, philosophical, poetic, full of spiritual insight, a woman on a wisdom path. It sounded like my cousin Julia Randall, back from the dead, but it was Annie Dillard, whom Julie had taught at Hollins.

As I ready my big four gates to install at the gallery, I start to wonder how they might in some way signal the American landscape. Dylan's wonderful ballad called *Tangled Up in Blue* has a subtle way of implying the scale of the continent from the Great North Woods to the fishing boats of the Gulf. I go at it another way and include what I am calling "spirit levels," water samples encased in copper so that they look like carpenter's levels. They are banded with copper, into which I have hammered the names of the water sources: Walden, Mississippi, Katahdin, Mammoth Spring. It is odd to claim the truth of this provenance as it's just water, but that's the point. I would not lie about this. As John Keats put it, "Beauty is truth, truth beauty, and that is all ye need to know."

My *Double Happiness* exhibit is finally installed, five tons of granite and bronze ramped into the gallery. Jammed knuckles, strained backs, but no one really hurt. I have a big opening, three different newspaper articles, and my favorite client buys my biggest piece outright, no hesitation. His *double happiness* was a twentieth anniversary and a

twentieth Princeton reunion. Mary throws a sixtieth birthday for me, and friends and family fly in from all over. It's a catered dinner with tables scattered among the sculptures, and my siblings roast me with teasing stories. Nate belts out a song, then chokes up. My mother, seeing a chance for humor, shouts out, "He's not dead yet." There's a raucous undercurrent of celebration among the activists like Ross Gelbspan and Paul Epstein, whose doctor group won the Nobel Peace Prize, along with Al Gore, two days before. It's a high-spirited moment, four generations celebrating, an epic event, and for weeks Mary and I bask in the aftermath. At the party we'd stood together at the microphone and spoken about *the wild courage of the loving heart.*

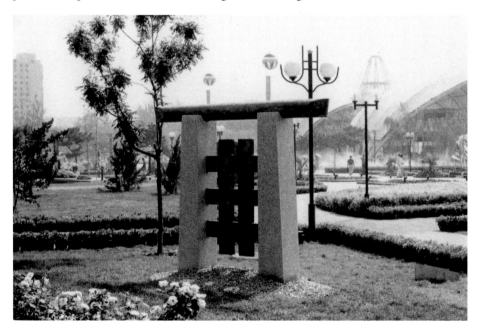

At the installation of *Double Happiness* at the edge of a lap pool, I am bantering with my client as I pour concrete for footings. I share my idea about a big sculpture park in the center of Boston. It turns out he's the head of real estate at one of the biggest banks, and we hatch a plan to join forces. I will organize the museum curators and public art people along with the sculptors. He will bring in the real estate developers and the banks. This mushrooms into a major initiative. I work the crowds, seeking donors, seeking leverage with politicians across the city. To get to the mayor, I am told I need to go through a particular power broker, so I pursue him relentlessly. Finally, on the phone, he concedes, "The mayor and I know nothing about art. We raise money for Catholic charities. And you are one persistent bastard. Good luck anyway." And the phone slammed down.

January 2008

We spend a weekend at Tom and Marty Bisbee's hilltop farm in Vermont. Tom's son John, a sculptor who uses only nails, has a retrospective at the Portland Museum of Art. John works with David Smith's intensity and focus and is among the most accomplished sculptors I know. There's a populist aspect to his art, as everyone understands nails, but he pushes it in widely inventive directions. With a halftime teaching position at Bowdoin, he's an antic and charismatic presence and for a time had a pet mouse in his pocket and a pack of four dogs that joined him in the classroom.

Murray Dewart

February 2008

Mary and I travel to Florence for a winter break and we call it our honeymoon, as we awaken to the bells of the Duomo and the sound of horses clattering on the cobbled streets. At the Uffizi Gallery looking at the Botticelli Venus, I am dumbstruck and Mary bursts into tears, recognizing herself in the painting. The radiant warmth of the feminine principle at the heart of the world is caught by Botticelli. My cool, cerebral intellect, parsing and analytic, can fail at this intersection, too quick to bring in history and ideas about the fate of the earth. Mary says, "Be here now," as she takes in the painting, tears running down her cheeks.

In San Guercio Val d'Orsia, we find an abandoned church on a long walk down a narrow gravel road as the sun was setting and the moon rising over a lovely Tuscan hillside rolling into the far distance. The alignment was perfect, east and west and also our hearts. To have come all this way and to find a church with no roof, open to the sky with a bell tower fallen to ruin, like the "Tintern Abbey" poem of Wordsworth that we read at our wedding. At supper in a warm trattoria, over lamb and a prize wine from Montalcino, we speak about our beginnings, when we first laid eyes on each other. Mary thought I was a highly original person. I thought she was absolutely beguiling, and I was drawn irresistibly to her mysterious and refined presence. She seemed almost perfect, and I, discerning and high-minded, I fell in love with her, that first encounter, on a Vermont hillside in 1970.

April 2008

The Boston painter John Walker has an exhibit on Newbury Street of large abstract canvases that are elegies for the casualties at the Battle of the Somme. His father was wounded there, and what is most extraordinary, *eight of his uncles* died there. I share with him the leftover trauma of my grandfather's early death after World War I and ask him the question "How many generations will it take to heal this?" His answer was unequivocal. "It will never heal." His father came back from the war without belief. There could be no loving God after the Somme. Late in life, John returned home to visit his father in his eighties, sitting by a fire on a damp day in England. "Where's mother?" John asked. "She's gone to be with her first love," his father replied. She had gone to visit the cemetery where an old lover, a wartime casualty, was buried, maybe Flanders. How, I wonder, does the light of art and art making go to the places of darkness to heal what needs to be healed? The curve of history is long, and it can break our hearts if we let it, and then we are no good use to anyone. If we are to call out to a loving God, it can't just be the easy sentimental one, among the springtime birds and flowers, but also the impossible one, among the ashes on the frozen winter ground.

April 2008

I am starting to think that my current sculptures are idealized versions of myself, part and parcel of my yearning. I can get bent out of shape, worn out and exhausted, angry at the war and the war-makers, but this sentiment is not present in the current work. The new sculptures are emblems of a serenity I long for and hope for, not a serenity I embody or often find. At my *Double Happiness* show, a willowy girl with a feathery headdress stood transfixed before my seven-foot sculpture, standing motionless for five minutes, then began trembling and rocking ever so slightly. The next day she came back with her boyfriend and stood motionless again, drawn deeply into the mystery of what I have made. Gary Snyder has a line about his art:

I am who this is. Who is this that is?

May 2008

Nate and Solana are an interracial couple not hesitant about their story and their style. All the details about their wedding in St. Louis have been shared, and every element carefully parsed. I have dyed some long silk banners a delicate blue green to hang in the greenhouse chapel. The wedding and reception are in Forest Park, and our families fly in from all across the country for the three-day extravaganza. There are banquets, barbecues, and a tree-planting ceremony, just as Mary and I had at our wedding. A cellist from the St. Louis Symphony has been hired to play. Solana's dad and I try on our tuxedos, horsing around with suspenders and clip-on ties like we're headed to a high school prom. He has a salt-of-the-earth quality, a grounded soul, deeply proud of his only child. The vows and ceremony go as planned with choral singing and an unaccompanied Bach cello piece. Nate and Solana file out with tearful families looking on. I follow them out the door, then notice Nate running full speed outside the chapel. *What in blazes?* In an absolutely complete surprise, *a sixty-piece marching band in full dress uniforms* suddenly sweeps in from around the corner of the chapel, all African American teenagers, the best band in St. Louis, cajoled by Nate and Solana to perform, escorting them and the whole wedding party through the park to the reception. There are honking cars that join the raucous noise of trumpets, snare drums, and saxophones as Nate and Solana, star dancers, sashay and boogie with antic high style through the park,

followed by grandmothers in wheelchairs and our whole dancing families. Nate and Solana have dreamt something large and carefully imagined in this ceremony of their youth and innocence, an epic ritual of family where time stands still. I am reminded of Yeats and his image of being caught between two immortalities, that of soul and that of tribe. The tree swallows dart above our heads as the music of the band echoes across the park, and it's another sunstruck moment, time out of time, the wonder and pageantry of life choreographed like a carved Grecian frieze, a family procession dancing under trees by a big river, a blessing of joyous and epic radiance.

Murray Dewart

Thank you to Mary, Caleb, and Nathaniel Dewart for contributing photographs.
Also thanks to Kathy Chapman and Stephen Seebeck.

Book design by Kent Rodzwicz, tintspace.com

Jacket photographs by Bruce Rogovin

Index of Photographs

Murray Dewart

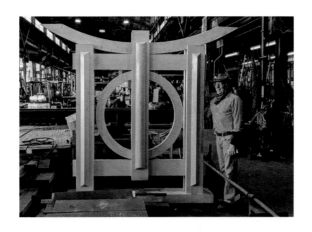

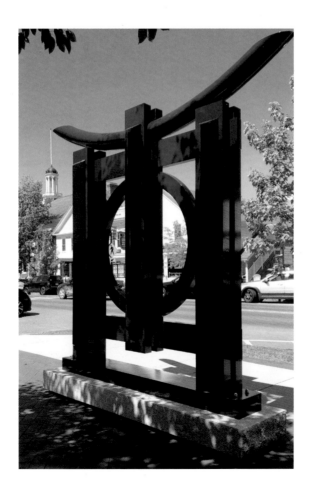

111

Edited by Ian Robertson
Book design by Kent Dodzwica, tintspace.com
Cover design by Christopher Bower
Type set in News Gothic Std/Adobe Gurmukhi

ISBN: 978-0-7643-6674-1
Printed in China

Published by Schiffer Publishing, Ltd.
4880 Lower Valley Road
Atglen, PA 19310
Phone: (610) 593-1777; Fax: (610) 593-2002
Email: Info@schifferbooks.com
Web: www.schifferbooks.com

For our complete selection of fine books on this and related subjects, please visit our website at www.schifferbooks.com. You may also write for a free catalog.

Schiffer Publishing's titles are available at special discounts for bulk purchases for sales promotions or premiums. Special editions, including personalized covers, corporate imprints, and excerpts, can be created in large quantities for special needs. For more information, contact the publisher.

We are always looking for people to write books on new and related subjects. If you have an idea for a book, please contact us at proposals@schifferbooks.com.